CARNY

AMERICANA ON THE MIDWAY

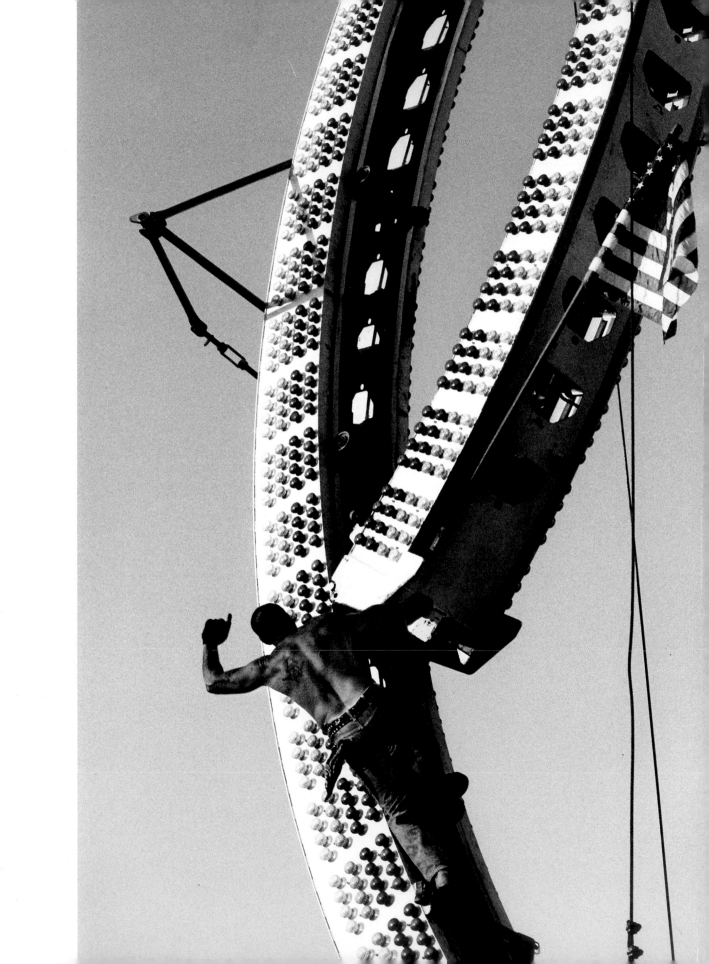

CARNY

AMERICANA ON THE MIDWAY

Photographs and Interviews by Virginia Lee Hunter
Essay by Peter Fenton
Lyrics by Tom Waits

umbrage editions

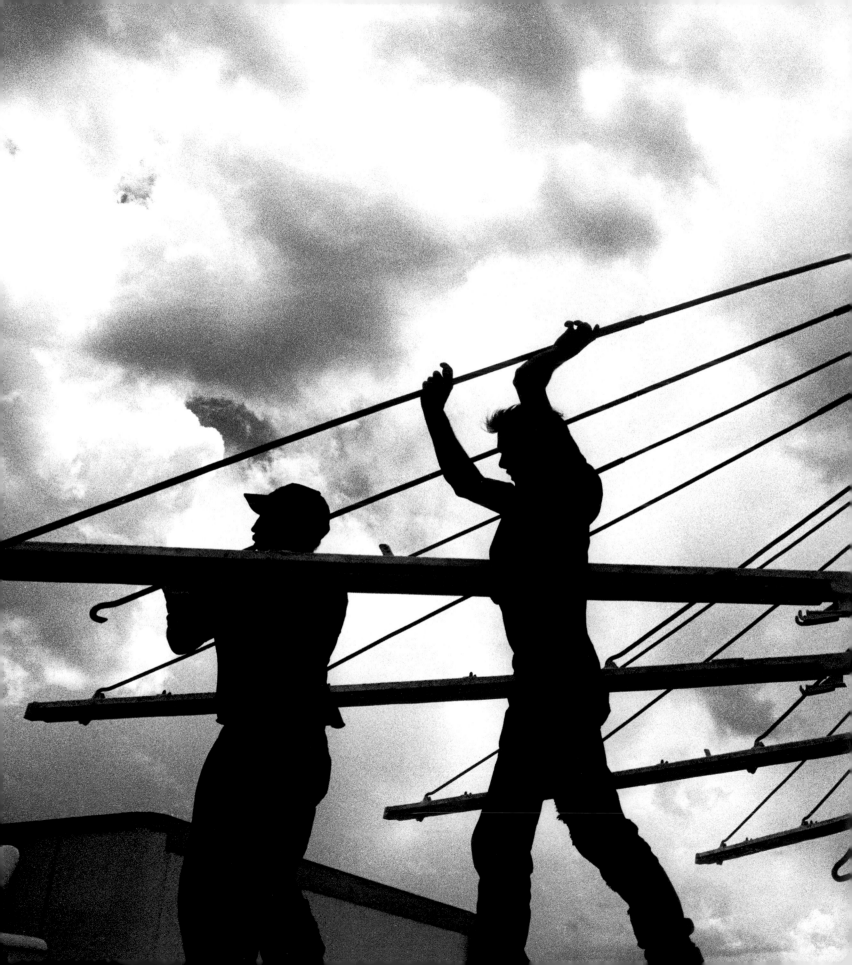

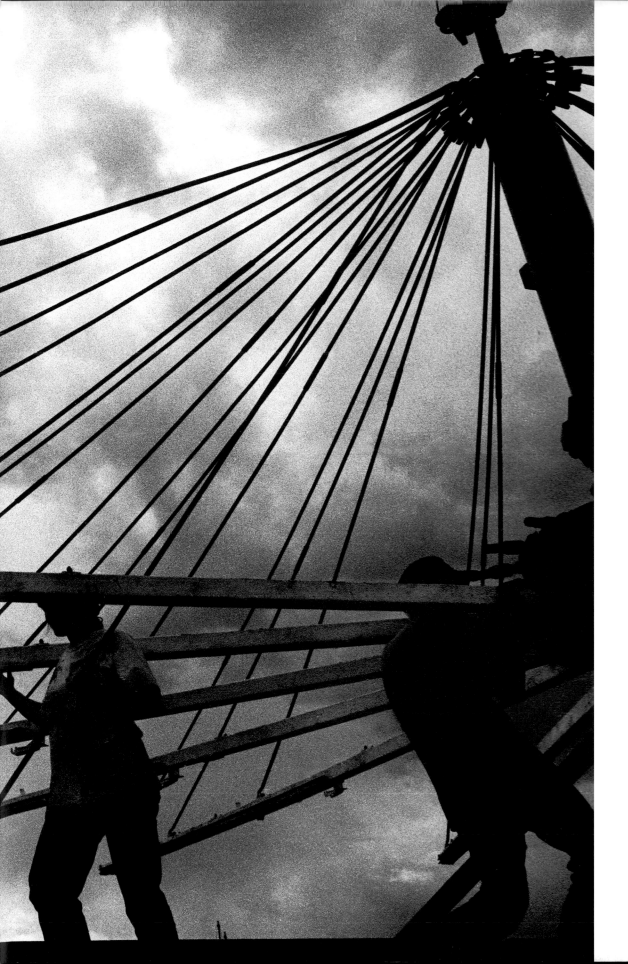

DEDICATION

To John "Grandpa Hack"
Hackensack, who's gone on to
play the "Big Show in the Sky."

To my carny pal, Paul McCann,
and all the other showmen
and carnies from the carnivals
who have shared with me their
stories and their beer.

And most importantly, to my
parents, Jinny and Bob Hunter,
whose love and support for me
knows no boundaries, for which
I am eternally grateful.

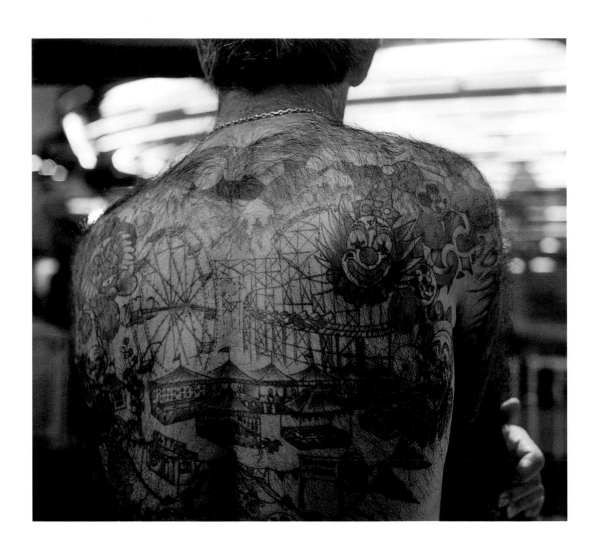

CIRCUS BY TOM WAITS

We put up our tent on a dark
green knoll, outside of town by
the train tracks and a seagull dump
Topping the bill was Horse Face Ethel
and her 'Marvellous Pigs In Satin'

We pounded our stakes in the ground
all powder brown
and the branches spread like scary
fingers reaching
We were in a pasture outside Kankakee

And One Eyed Myra, the queen of
the galley who trained the
ostrich and the camels
She looked at me squinty with her
one good eye in a Roy Orbison
t-shirt as she bottle fed
an orangutan named Tripod

And then there was
Yodeling Elaine the
queen of the air who wore a
dollar sign medallion and she
had a tiny bubble of spittle
around her nostril and a

little rusty tear, for she had
lassoed and lost another
tipsy sailor

And over in
the burnt yellow tent
by the frozen tractor, the
music was like electric sugar
and Zuzu Bolin played
'Stavin' Chain' and Mighty
Tiny on the saw and he
threw his head back with a
mouth full of gold teeth...
...And I wish I had some whiskey
 and a gun
my dear
And I wish I had some whiskey
 and a gun
my dear

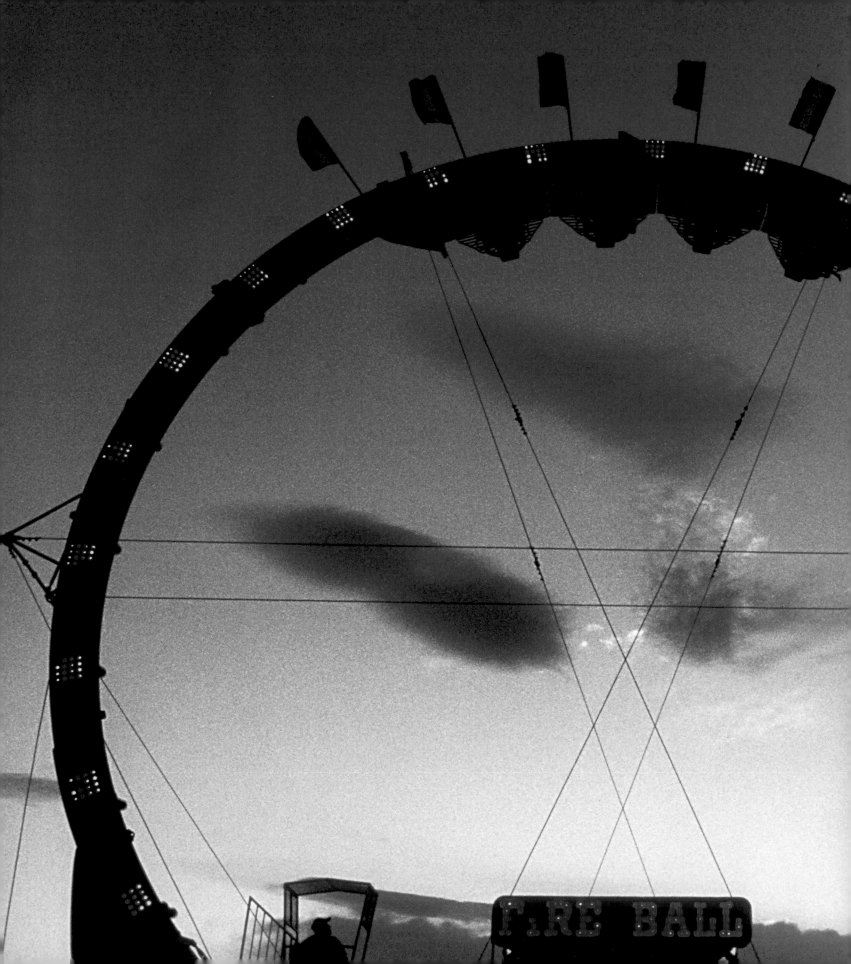

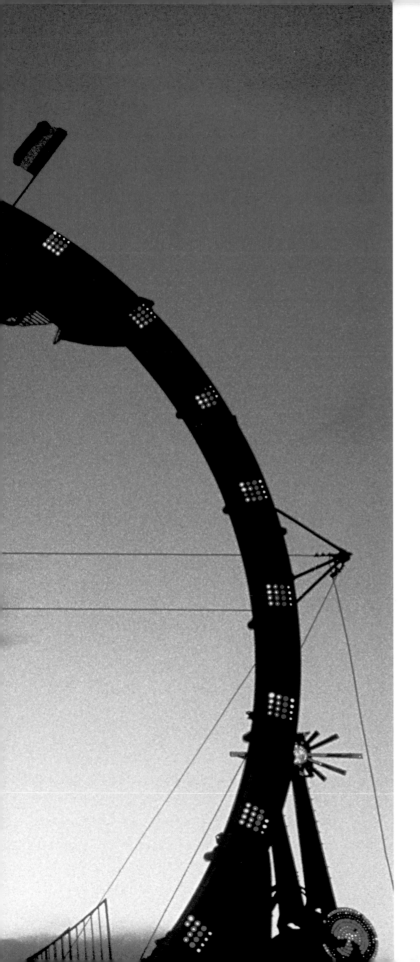

Essay
PETER FENTON

As an American institution, the traveling carnival stands shoulder-to-shoulder with the Chicken McNugget, Home Shopping Network, Christmas fruit cake, Girls Gone Wild, the 700 Club, and the Yellow Terror Alert: each a unique thread woven into the fabric of our popular culture and of dubious value.

Take carnivals, the subject of this superb book: they're cheap, loud, dodgy and crude. So are carnys, the people; that's one reason I love them.

But carnivals are also colorful, rousing, brassy and...sexy, judging by the number of teen couples who trade hickeys between screams while strapped in the torture chambers more commonly called thrill rides. Carnys, too, have an appealing side – once you get past the aggressive come-ons and questionable haircuts. All the more reason to love carnivals and carnys both.

Armed with only a camera, Virginia Lee Hunter has captured the midway's dual allure: the innocent and sweet; the cheap and flashy. For me, turning these pages is a vivid return to the midway—shoes caked with straw and manure, cotton candy in one hand, teddy bear in the other, wallet emptied though the night is still young.

Thanks to a friend whose father owned a traveling "rag-bag," I was introduced to the carnival world in my teens. I was a college-bound bookworm, but working on the rough-and-tumble midway held surprising appeal. Entranced, I ran away from my predictable future for a time, acquiring an abundance of alternative life skills: how to sleep under a trailer when money was tight; how to drive a girl home when she arrived at the show on a tractor; the proper way to handle a difference of opinion when my co-worker was an escaped felon; and the anecdotally most successful method of hoodwinking a six-foot-four-inch, 240-pound local sucker without getting punched.

Had it not been for my friend, I would not have received such training. The midway is a closed subculture, with a thick, candy-striped line between the smart crowd that's "with it" and the pathetic "marks" that are decidedly not. The distress call of "Hey, Rube!" will still move self-respecting carnys to drop what they're doing and hurry to the aid of a comrade in need.

Incidentally, there is something about the capturing of their faces on film that makes carnys nervous. I never asked why. But a good guess would include outstanding warrants, bad debts, and the desire not to have one's current whereabouts publicly revealed. Which makes Virginia Lee Hunter's photographs all the more remarkable. In order to take her candid portraits of carnys, she had to first gain their acceptance, no small task for an outsider lacking an introduction. Her ten-year immersion in the world of sawdust, grit, and glitter has paid off in the revealing images you see here.

Everyday people become carnys to flee the dismal pulp narrative in which they've been cast as victims. Lousy parents, a bad marriage, the $5.15 federal minimum wage, forbidden love, and the aforementioned legal issues are just some of what spur them to flee the familiar for life on the road. Many don't last for more than a day. They discover that elephant ears for breakfast and sponge baths in gas stations aren't desirable options for the long term. And on the midway, relationships, particularly the romantic sort, often have the longevity of a mosquito. In the time it takes for that mosquito to draw blood from a townie's arm, the carny she eloped with may be off plying another love with gifts of plush frogs, spun art, and Dale Earnhardt, Jr. posters. (Leaving the townie with nowhere to go but the bus stop and home.)

Much like aspiring Harvard students, only one in a hundred or so applicants pass muster and become full-time carnys. They endure, perhaps, because their drive to escape trumps the hardships and the indignities of the carnival circuit. Keep moving, that's the key. Stay ahead of the hounds. Run fast enough and all the tattered baggage is left behind, the sky is clear and the sun is shining bright on that ever-unfolding ribbon of open road that always, always conveys hope. Even when the carny's car is a beater, gas is $3.25 per gallon, and his job is sixty hours a week of dipping apples into a vat of molten red glaze.

Escape. I was tight with many carnys for years and knew them by nicknames only: "Fred X," "Ghost," "Squirmy," and so on. To probe further would have been considered a hostile act. Even nicknames could change on a whim, the prior identifiers never referred to again. One guy carried no I.D. None. If he died on the natural or was shot by a mark (he had a way with married women and could parlay a free teddy bear into a back-of-the-tent interlude) no one would know who he was. He preferred it that way.

While turning carny enables one to obliterate the past, there's another, grander perk: in a bifurcated economy, where hopelessness is pandemic and you have no future, the midway allows you to become someone else. Meaning that on the midway, one might encounter a "dentist" with only three teeth and a "ballerina" who tossed aside fame to pump helium into balloons. After an apprenticeship of hardship and bullshit, of broiling sun and penetrating sleet, of bounced paychecks and stoned camaraderie, of empty midways and bountiful "red spots," of scamming marks and gifting a crying child with a shaved ice—the ordinary Joe is left behind; the carny emerges in a new guise of his making.

Freedom. The carny finds it hawking cotton candy. Or tearing down the Ferris Wheel all night, packing it on a trailer at dawn and driving it to the next county fair or church parking lot, arriving at noon to restore the wheel to its former glory before nightfall. All for the same chump change he threw in his boss' pimply face back at the Dairy Queen or Kinko's, where life was passing him by until the carnival chugged into town and he left with it, future uncertain, but infinitely preferable to the one he saw coming.

Turning carny brings status. The freshly-minted carny becomes one of Us, in an Us vs. Them world, the chief benefit of which is the sense of having a leg up on Them. Them work nine to five, while Us work eight until midnight—though it isn't really work, it's fun, like being rock group roadies or movie

set grips. Us control who among Them win the games, how long the ride lasts, whether the popcorn we hand Them is fresh or stale. Us is cool people—whether we look it or not. Us is performers—you know, show-biz folks. And the midway is where we perform: boiling hot dogs, guessing weight, sweeping coins off a counter.

Cash. In an increasingly cashless economy of debit cards and electronic transfers, there's something enthralling about accepting payment with worn paper money and tarnished coins. The real thing. Cash has a smell. A taste. The heartache, the humiliation that the mark (one of Them) went through to earn it, along with the struggles of those who earned it before him, is present in every scratch, crease, and smudge. And then, that stored value, that stored aggravation, is simply...dropped into the carny's palm. For a dry slice of pizza, a nausea-inducing two-minute thrill ride, the chance to land a dime on, and win, a glass plate that's worth only a nickel.

Come closing time, the carny dumps that day's cash into a mound, and as he counts it, he may marvel that such great effort was squandered on ephemeral pleasures and trinkets. And then he stacks that powerful history into neat piles and fantasizes about what he will do with his share.

When I was a carny, the money didn't last long in my wallet. I tossed it away with less care than the marks. As did my peers. A wealthy carnival owner, an imposing man who had started on the bottom, once confided to me that his employees spent their cash on "food and beer, not necessarily in that order." He was dead on, if cigarettes are counted as food.

To a carny, money in the pocket is kryptonite. What is quickly earned is immediately frittered away, as if, along with his straight job, the carny has abandoned all common sense. I have watched in amazement a fellow carny blow a week's pay on lunch at a Burger King, buying one of everything for himself (most of which he didn't touch), and picking up the tab for any pretty lady he thought might be impressed. He suffered through the rest of the spot on stale hot dogs and flat soda, finding solace in the memory of the hour or so he was BK's #1 Big Spender.

Severed from convention, the carny finds order in personal whim. Eat pizza all day? Fine. Drink on the job? No problem. Give a hundred kids free merry-go-round rides? Sure thing. Quit because the boss looked at you the wrong way? Damn straight. There's always another midway with a hole to fill. Carnys control their own destiny. That's not as hard as you think, because the future is whatever they desire at any given moment.

So don't lend a carny money. I learned that expensive lesson early on. When a carny asks to borrow a "double-saw" or a fifty, it means that he is preparing to leave the show. He will soon be gone, along with cash from a couple dozen equally gullible lenders, his future temporarily secured.

It's a lifestyle that gets in your blood, as Virginia Lee Hunter will attest. She revisits the midway year after year in one part of the country or another. I seldom do, but the possibility sustains me. Chained to a desk, the lure of the forbidden is strong. Maybe one day I'll succumb. Until then, Virginia's wonderful book will more than make do.

SMOKEY: RIDE JOCK
AS THE BIG WHEEL TURNS!

That little girl come to my ride every fucking night, on the hour every hour. That ride right there attracts a lot of women. I met more women on that ride last week then when I worked the '93 mardi gras. You got to be hustling though.

I've worked the rocket plane where this chick sat here–she was an exhibitionist and her boyfriend sat there and he got off on it. She was wearing a real loose titty top, and her tits would come out. I would look out and yell, 'boobs!' and she'd pull her top back up and her old man sittin' the whole time seeing this, laughing as hell and just having a good time! That's what a lot of this is. I have seen girls in the fun house doing cartwheels in front of the mirrors wearing a real loose top and no bra. They don't care, they're just showing off. And in the Scooters, some chicks sittin' in their short skirts with no underwear on, drive by the operator all time showing it off. They think its blowing our minds, but to us, we see it all the time! We start rating them! Eight, Nine, Four.

When they have fun, then we have fun.

There's a lot of us out here that are just looking. We don't have the "rap," but some of the other ride jocks do. They can have any girl. Some nice looking chick comes up, shakes her boobs, shakes her tail, says the word. There's the tongue and there they go. I'm sure you've seen that one!

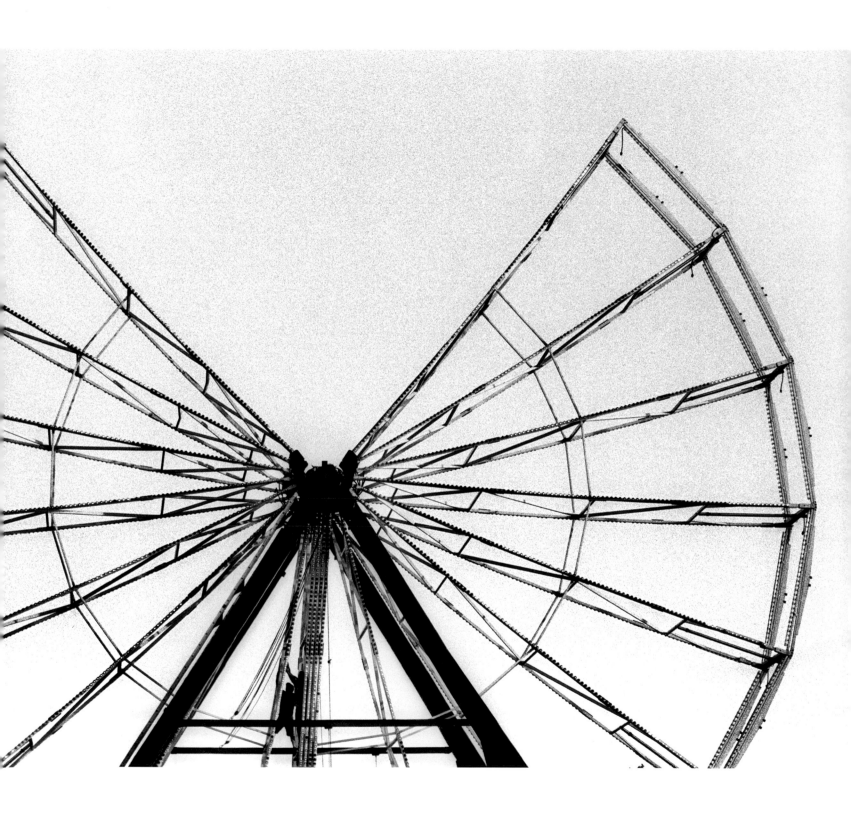

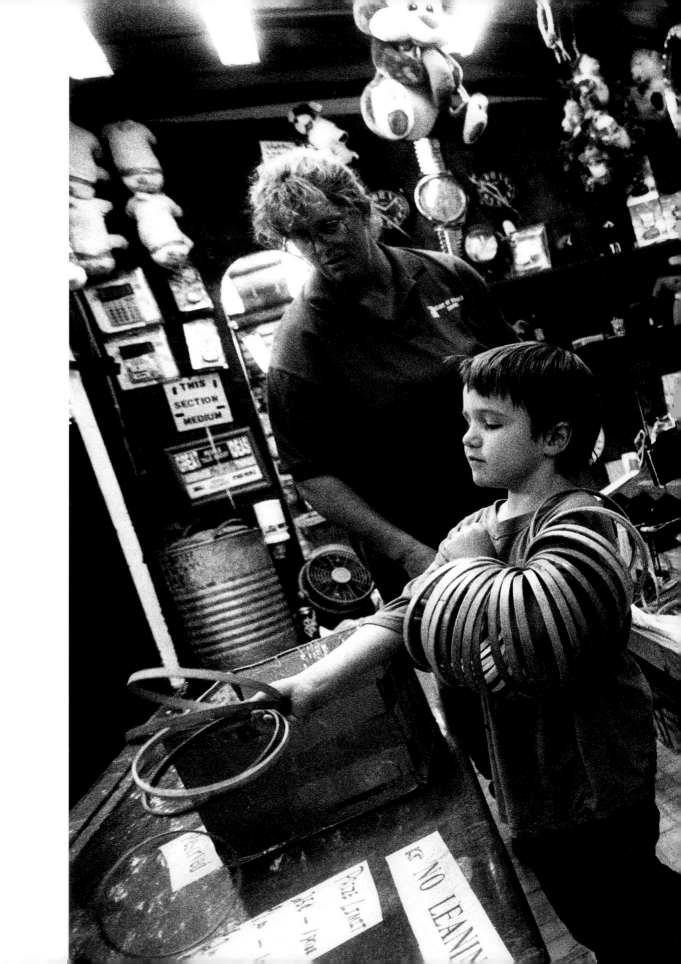

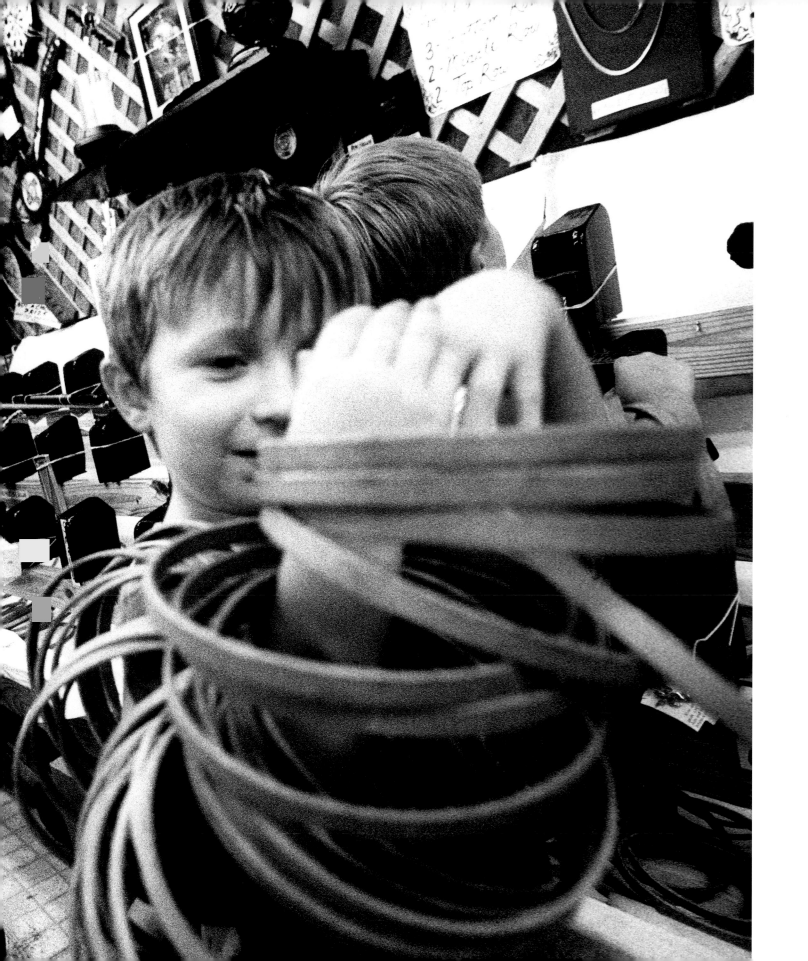

PAUL: Ticket Taker

Never rode a ride and don't intend to. I never did want to go around in a circle and get sick. I just never felt no emotion for that. Naw! I don't have to ride a ride to get a girl either. I can usually go down and find some. But not by riding no ride. No thank you!

Back in the old days, the carnival used to be the first place the law would look, if a kid'd run away from home. They'd look on the carnival lot cuz they knew that's where they'd come to get a job. And three-quarters of the time, they were right. They might only be thirteen or fourteen years old. Now the kids don't even come out to ask to travel no more.

The reason the man at the carnival took me when I was ten years old is because I'd lied to him. I said "I'm seventeen." He knew I wasn't seventeen, but he just took it.

The first carnival always had your Ferris Wheel, Merry-Go-Round, and your 'Tilt' [Tilt-a-Whirl]. We used to have a few little ground mount kid rides like the lil' ol' cars, and little donkey pull carts. Not very big carnivals. There were a few joints like the flat stores—Lucky Strike Pitch, Basketball, Milk Cans, stuff like that. The ol' Lucky Strike Pitch is where you win a pack of Lucky Strike cigarettes if you hit in the circle. They were either a dime or a nickel. For the little kids you had the Duck Pond. You had a Ring Toss which we have one now on the show. I never did want to work in a joint. I like to wander around and talk to people. I'd have myself a good time. Not be caged in a joint to make money. It used to be you never helped a jointy out and he never helped you, but now we work together.

I was married for thirty-two years. My wife stayed home in Indiana with the kids. Every week I'd send money home. Every week! She'd raised the kids and I'd see them in the wintertime and that's the only time I'd see them. I'd be gone the rest of the time. I went up there for Christmas right before she died. I went to see her, for the last time. I bought her a beautiful Christmas present. She hugged me and told me, "Paul, you ain't forgot what I like did ya?" "Nope." I never had either.

I got a daughter and a son. He's an officer in the Navy and the she's a nurse in Indiana. I see them maybe every year or so. She wants me to get off the road and come live with her. Naw! Naw! I get off the road as old as I am now, I would be dead within a year. I would have nothing to do. Who's gonna hire a 60 year old man? I don't feel like retiring. Just sit back and die? I do not feel like sittin' back and dying. I want to be out here on the road.

Carny life is in your blood. You're out here in the free air every day. You're not sittin' behind a desk, fenced up in a little bitty office. You got this whole world ahead of ya. You can see the beauty of the flowers and the trees everyday out here. You can't do that penned up in an office in the city. I'm an old man that's happy as a lark out here. Can you say that? I did settle down, only out here on the road.

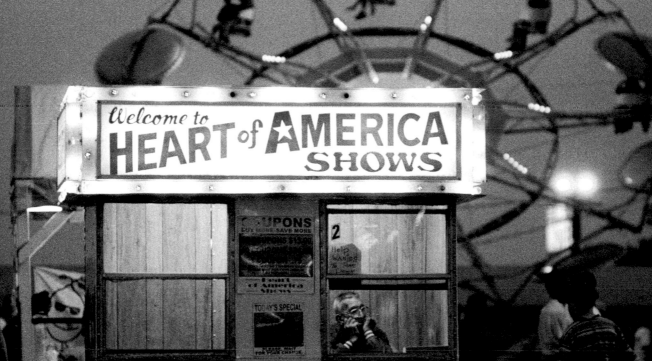

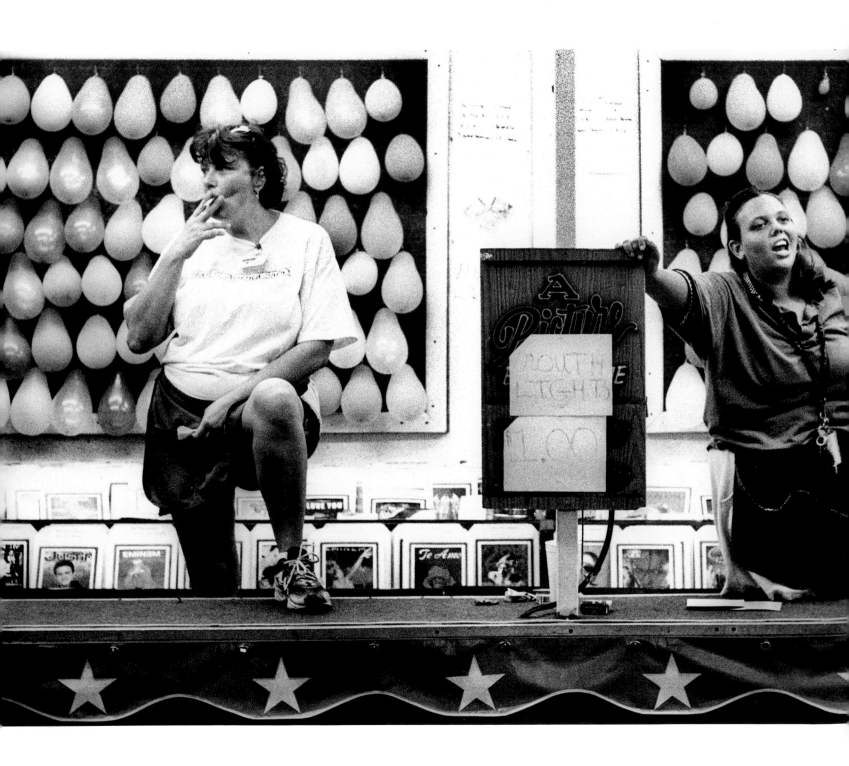

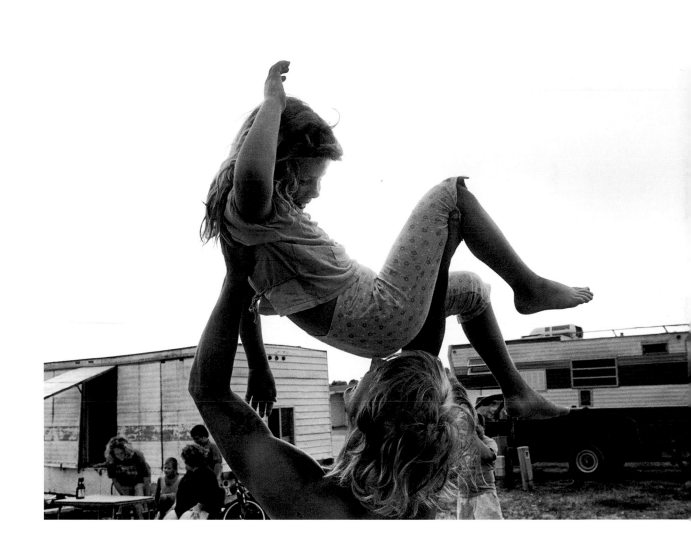

ROBERT: Giant Wheel Operator

It's all wheels out here. Everything runs in circles. I fell in love with this ride here, the Giant Wheel, the first time I got on it. I been in the business about sixteen years, and moved several rides but this one I fell in love with. They didn't have one of these when I was a kid.

The Gondola in the Sky [The Giant Wheel] is the biggest portable wheel. It's the "Billboard of the Midway." It's a fascinating piece of machinery, but that's all it is–a piece of machinery–though, it does have a life.

I got a crew of six that works with me. I'm a baby sitter, a Momma to all these guys. Most of them are young and have never been nowhere. I try to be as honest as I can with them and steer them in the right direction. Most these ride guys out here are underpaid and overworked. But this gives them a home, or at least a sense of a home.

I hope the carnivals never die. It's sad that it's changed. It used to be all family; generation to generate type thing. I seen a change in attitude around the carnival. We got a bad reputation anyway. You run across everybody in the world that's on the run, or on the move. They wanna come to work be a carny. They come out here and they don't care about the reputation cuz this is not their life. Most of the ones that do that: like they get caught stealing in the mall, or they get caught with drugs, or this or that. But the ones that have been here for years and years that take this as their livelihood, and the seriousness of it, they are 'show people'. Just as an actor goes out and does his job, or a band that goes out and plays a concert, you put on a show for these people and it's business. If you don't treat it that way, then you don't last long, and sometimes give the carnival a bad reputation. We are out there for one reason, to entertain these people.

I had an eighty-year-old woman come on my ride when I was running the Tilt-a-Whirl. She told me that she'd been riding Tilt-a-Whirls since, well whenever there was Tilt-a-Whirls, I guess. That was always her favorite ride. That day, she made my day. I'm a radiator man by trade, really. I learned welding and stuff like that, which I can make a lot more money in than being out here. But money is not what it's all about sometimes. I've already been up and down that road.

You know what they say about the difference between the men and the boys is by the size of their toys. Well, I got the biggest toy out here!

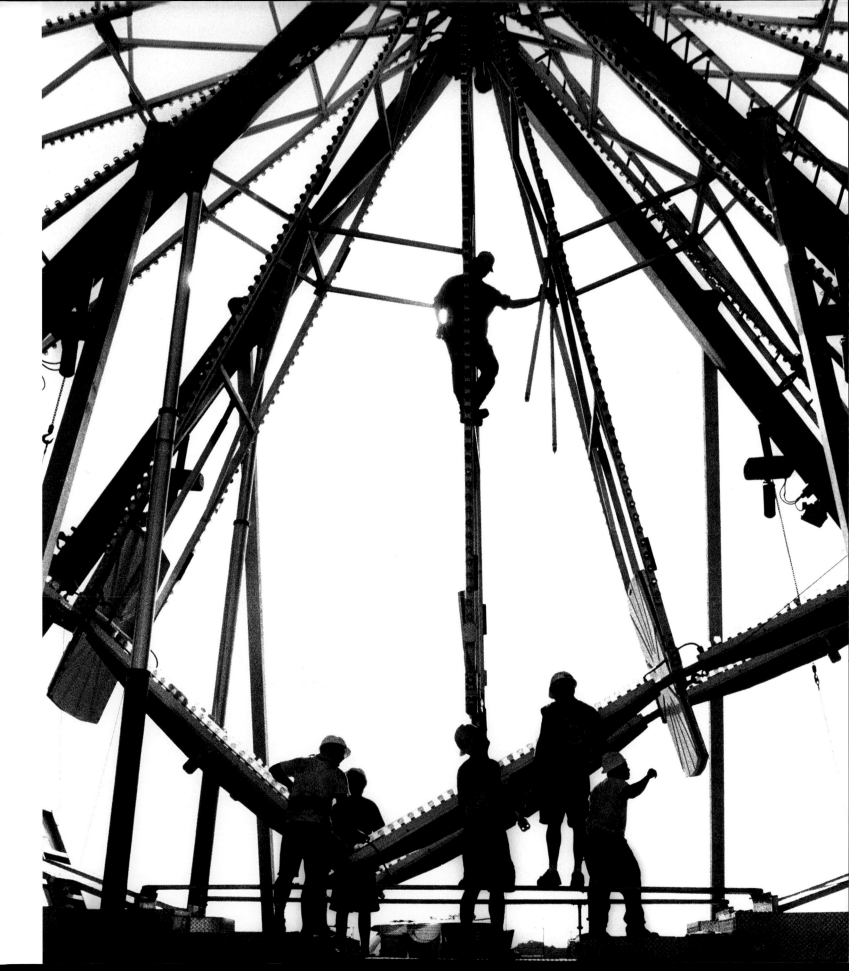

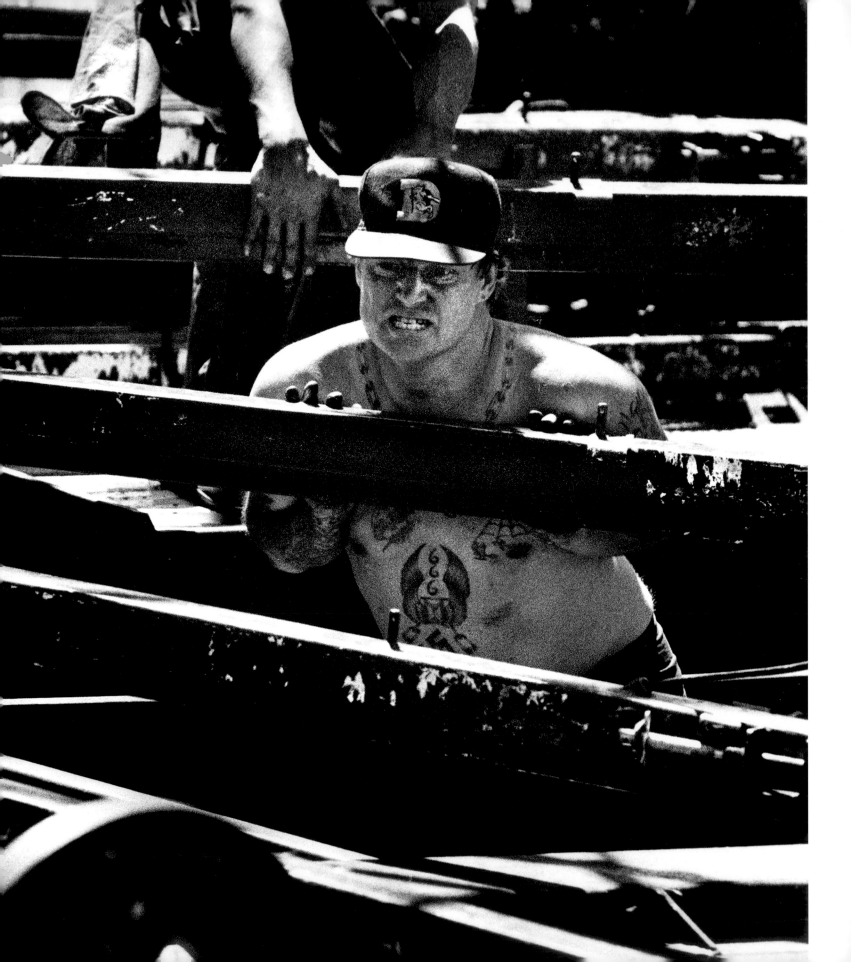

RALPH: RIDE JOCK

We're Ride Jocks, not 'Splinterheads'—Jointys, Stickjoints, Games. Splinterheads are called that cuz they work around wood. Their joints are all wood. The rides are all heavy iron. We're heavy metal!

This carnival life is a good life. If you ain't got nothing else, this is where it's at. It's party town. We work all day and party all night. We throw down every night. We got a bar-b-que out there—steaks, burgers, hotdogs, beer.

Every now and then there's a sweetheart on the road. Just for fun. They're around. They don't last long. Relationships don't last long when you're out here if you're just traveling.

We'll fight amongst one another. We knock the hell out of each other every once in a while. But that's between us. Nobody else could come on here and do that to us. One day Ted may walk up to Jack and take a two by four to his head, but the next day some townie come up to jump on Jack and Ted will be taking a two by four to their head. We take care of our discipline inside our own family. We discipline ourselves. The few, the proud, and the in-between.

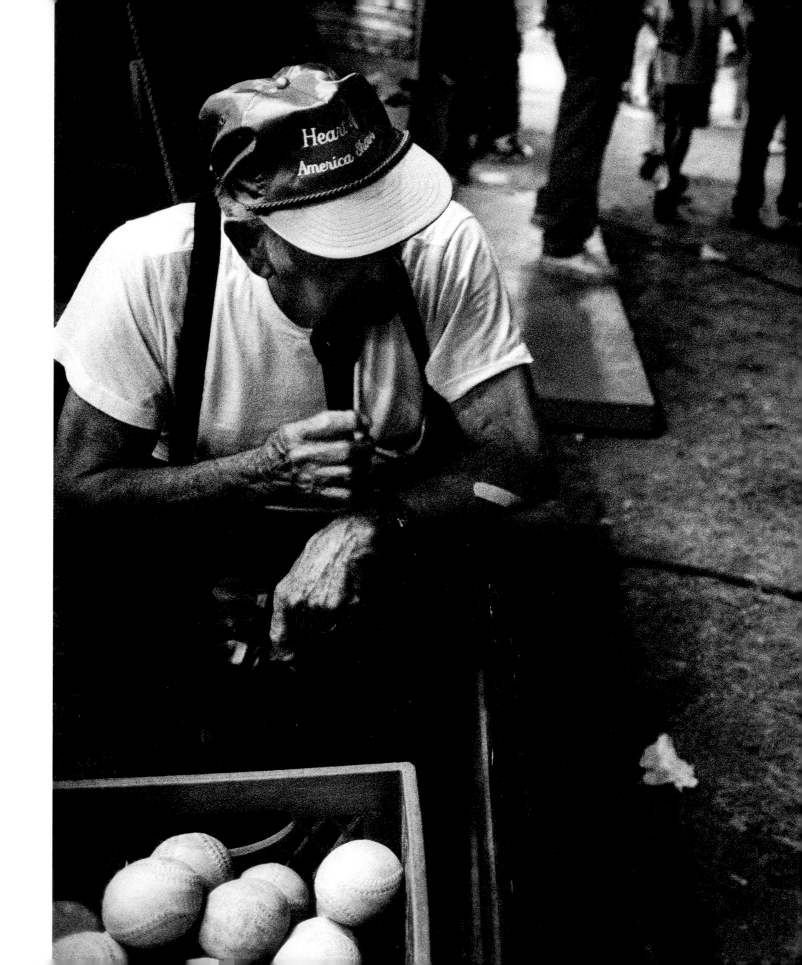

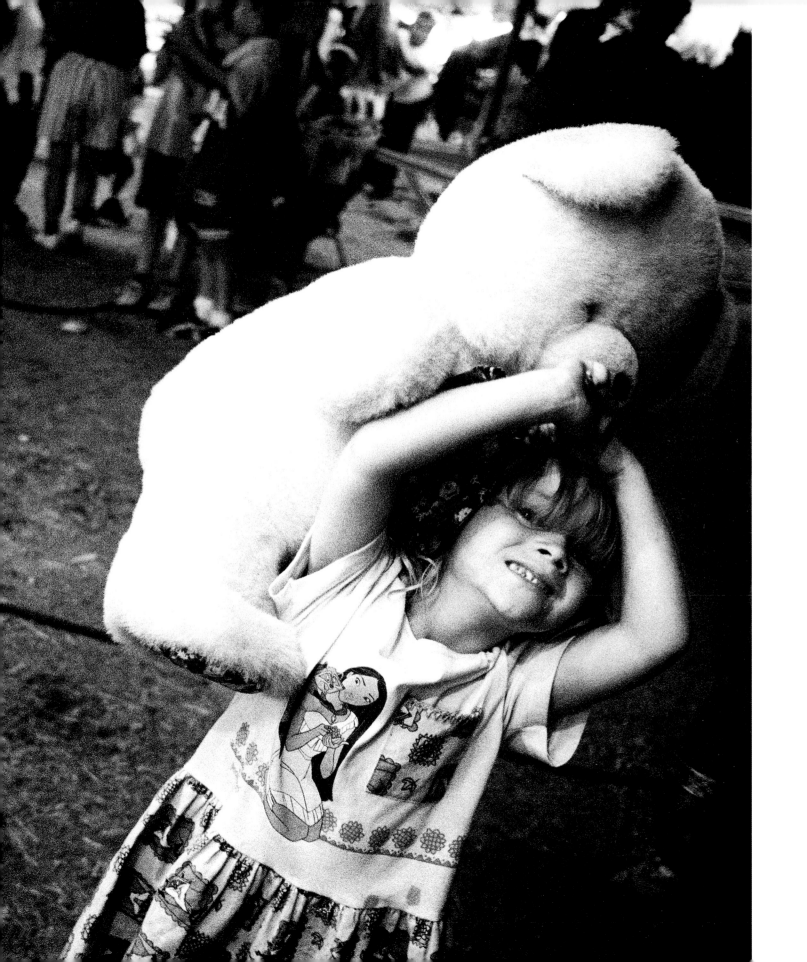

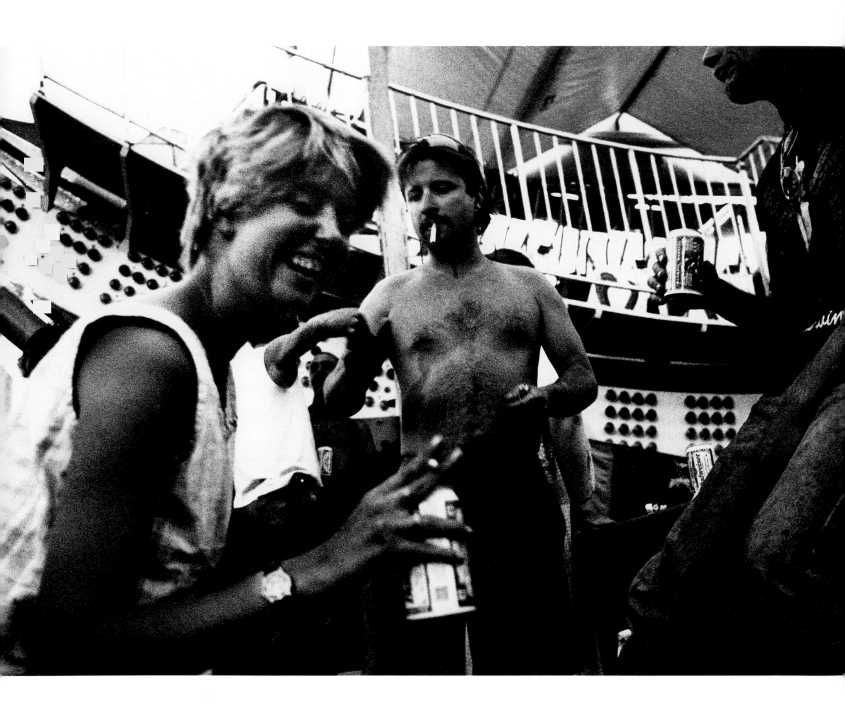

RIDE JOCK JOKE

This cannibal walks into a cannibal restaurant and they hand him a menu. He looked at it and the first thing on the menu is 'carny burgers'. He says, "OK, that sounds good, I've always wanted to eat a carny!" So he looks further and the first one on there says, "hanky pank burgers, 6 bucks!" Next thing it says is 'alibi burgers', twenty dollars! The last item is 'ride jocks', that cost 250 bucks! The cannibal calls the waiter over and says, "There must be a mistake here. I know a 'hanky pank' agent's gotta be worth more than a ride jock." He says "yeah they are good, those guys are very good at grinding." He says, "And I know an alibi agent is way more better an asset than a ride jock. Why is he priced lower?" The waiter said, "well they are just a bunch of liars." "So, why is it that a ride jock burger is 250 bucks?" The waiter says, "Have you ever tried to clean one of those things?"

–As told by Dutch, a 'Spinterhead'

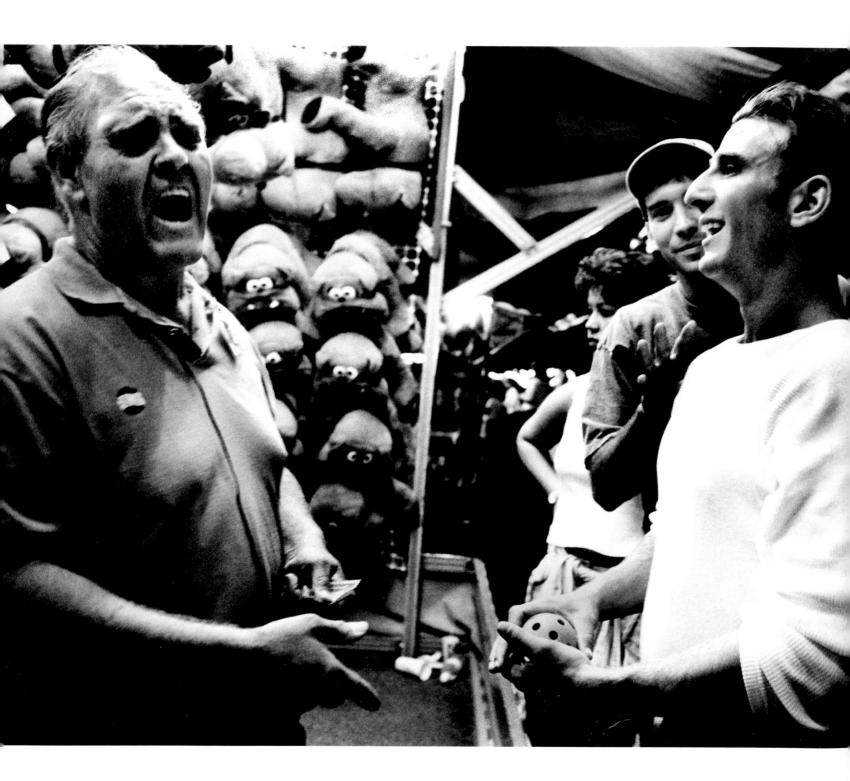

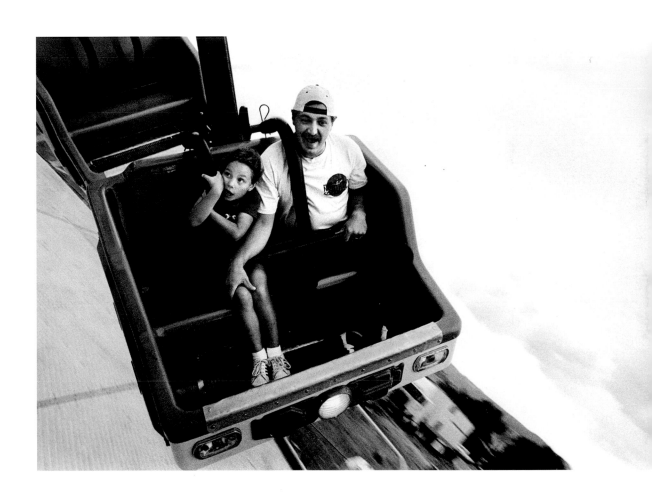

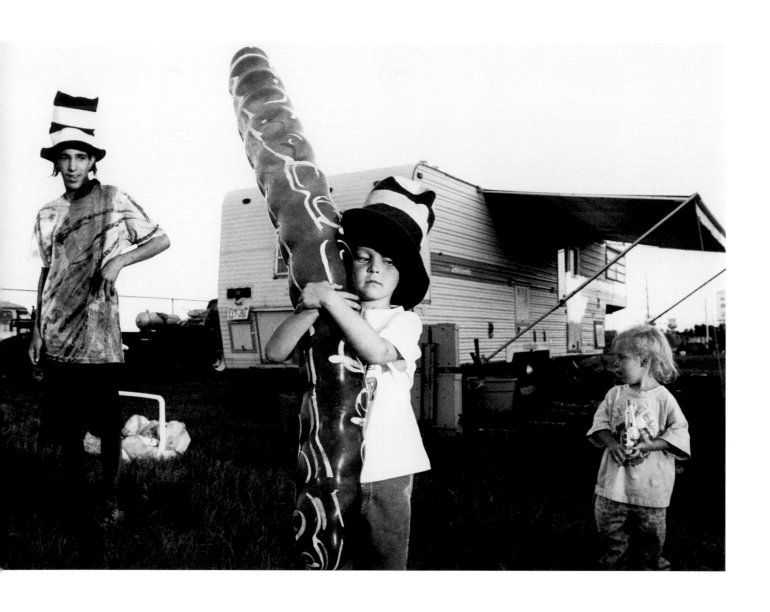

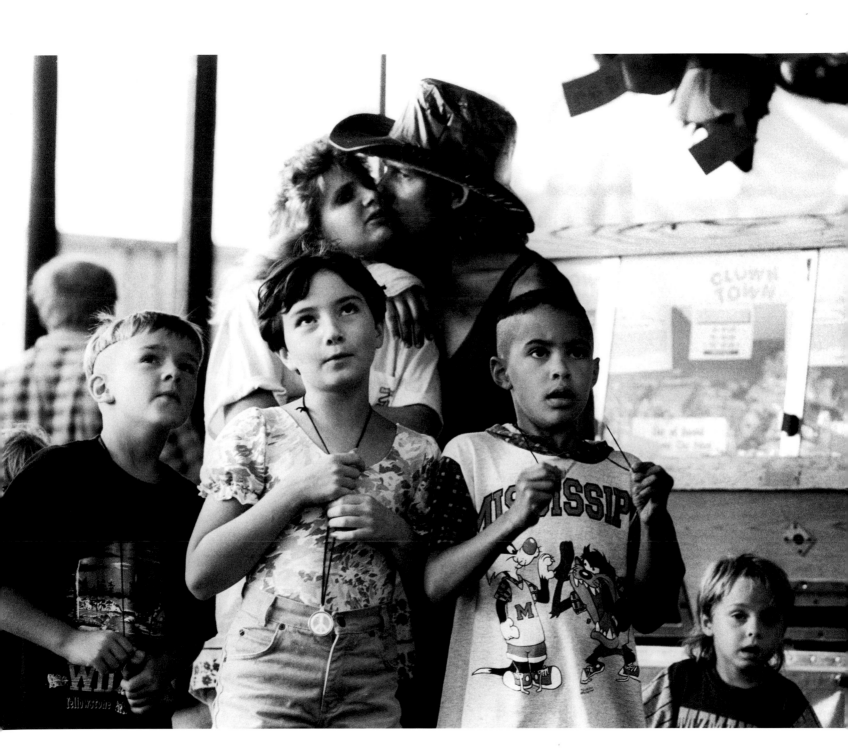

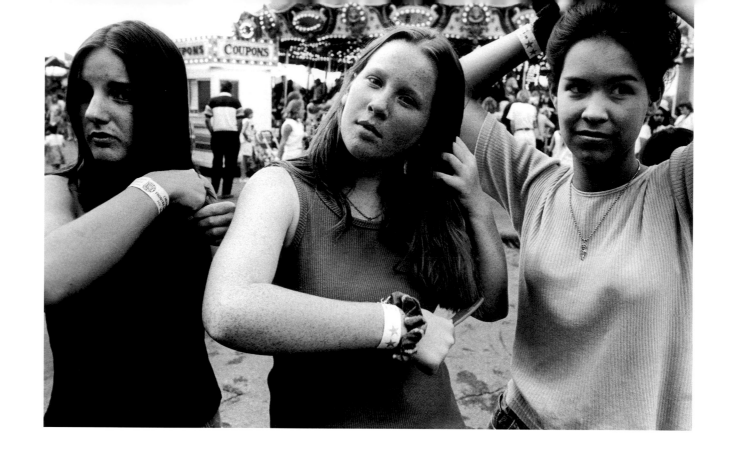

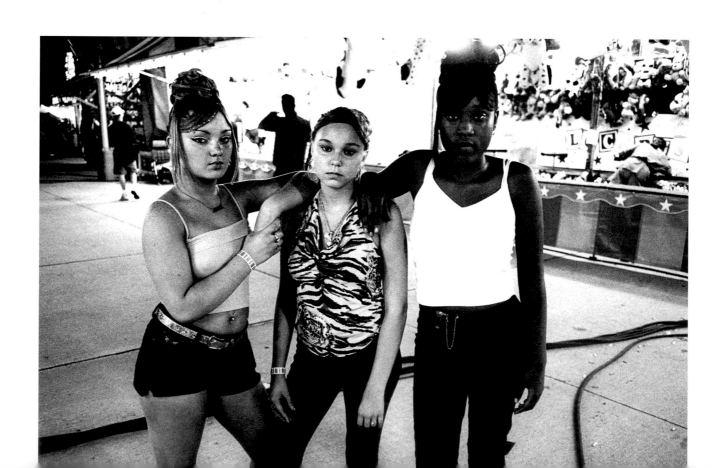

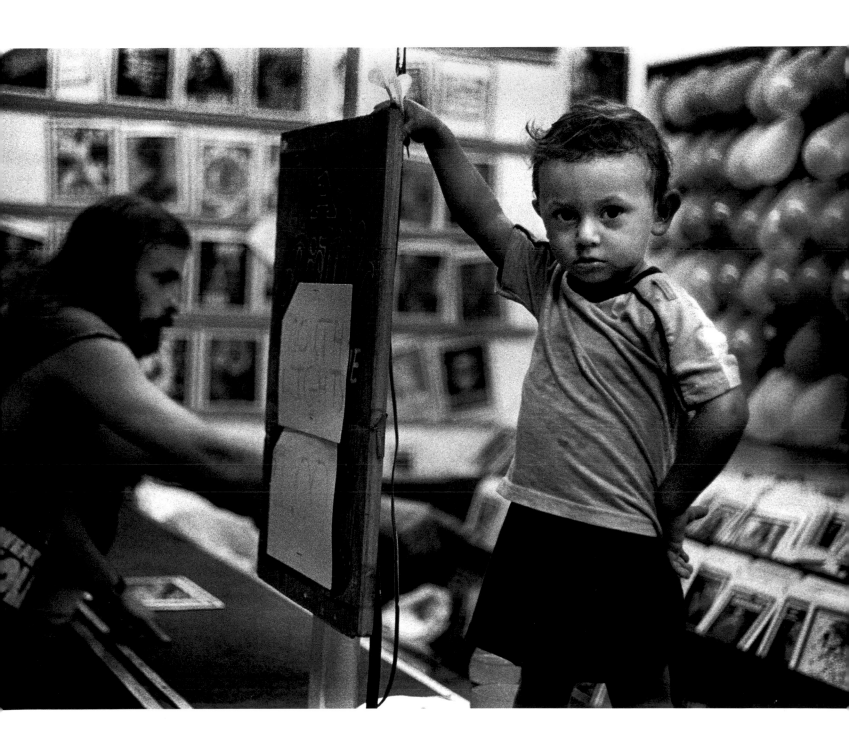

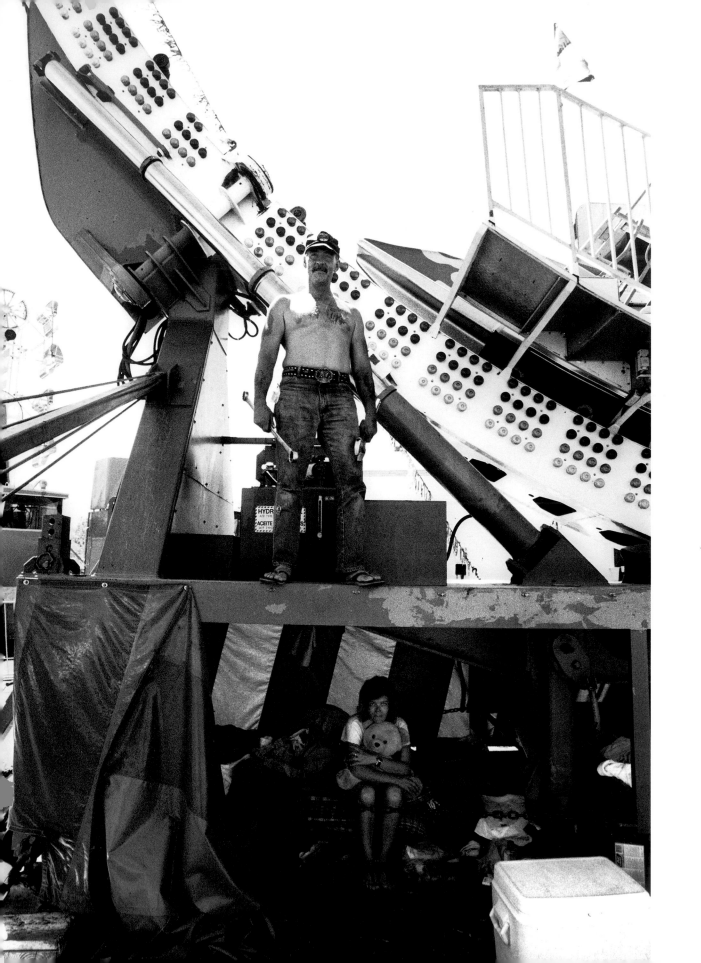

CYBO AND DARLENE

CYBO: I'm sergeant first class retired from the military. I was Airborne Ranger. 173rd airborne, 95th ranger, 12th infantry, 3rd Spear Head division. I was a jump instructor when I left. Tried to stay home for a while after I was retired. But sittin' around doesn't do it. I started gettin' in a little trouble so I said, "I'm gonna hit the road for a little while." I joined the carnival and that's what I've been doing. Been on the ring all this time. Sometimes I feel like I'm more at peace with myself when I'm out on the road. Its kind of like the military. There are certain times and certain things to do. It kind of reminds me of being in the army. This here's my family. I've gotten in with these people. I was married for twenty-two years. I got seven children and six grand children. I just met Darlene in the last spot. I got her the job working in the duck pond at this spot.

DARLENE: I've been on the road before with a truck driver. That was the worse thing I ever did. This is my first time being on the carnival, I love it. I used to be a waitress. I like dealing with the public. I used to work in topless bars and make five, six hundred dollars a night. I was only twenty years old. I had my daughter and thought, "Nope, no more of this." My kids are nine and one will be eight and the other be six. Two boys and a girl. They're in foster care right now. They say I party too much. And this [being out on the show] is the most I've partied in my life. I gotta quit and get my stuff back together and get back down to Greeley. They're doing their review in thirty days and say I can have my kids back.

DARLENE: I love sleeping under that ride. It's the coolest place except they set the ride up wrong. The sun comes up and he has to shut that curtain cuz he can't leave it open at night cuz the breeze comes through. But it don't bother me. I been passed out when its been going [the ride]. You think it'd be loud but...

CYBO: [interrupting] She says; "I can't sleep under there!" I says, "Go ahead and lay down." "I can't sleep under there!" She went over there to lay down and not even five minutes later I come down to check on her and she's going "sgnas shwoo" [snoring] .

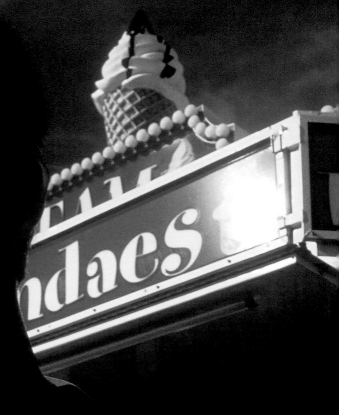

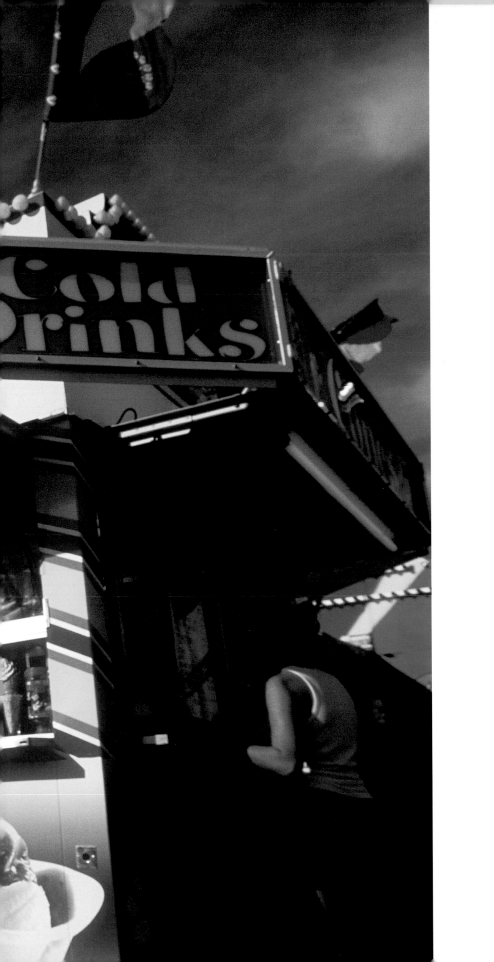

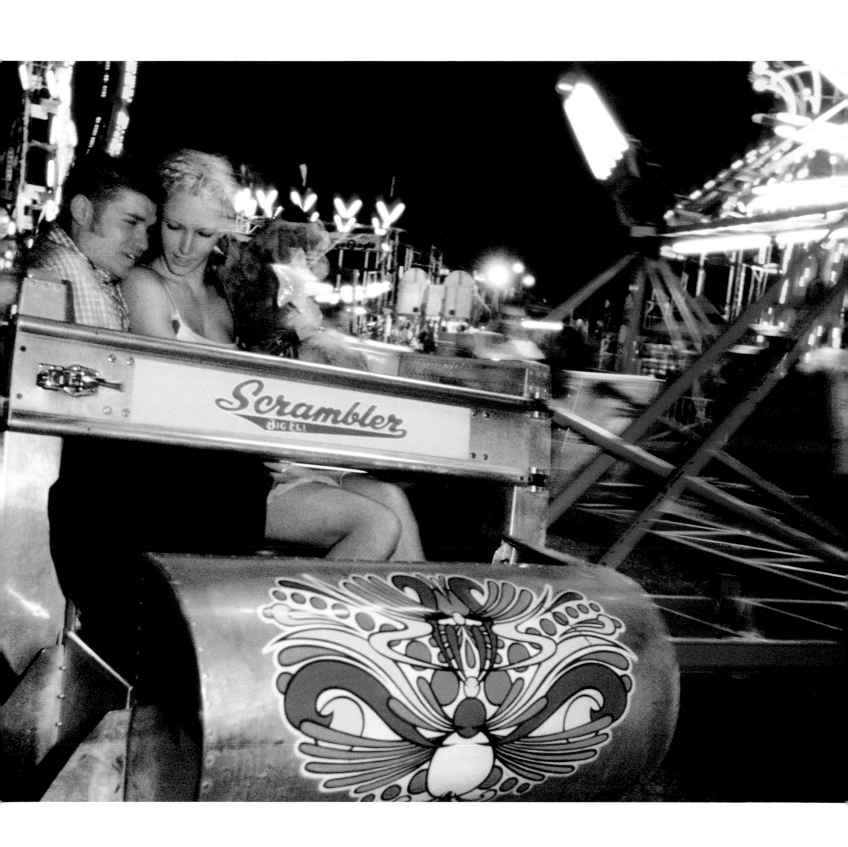

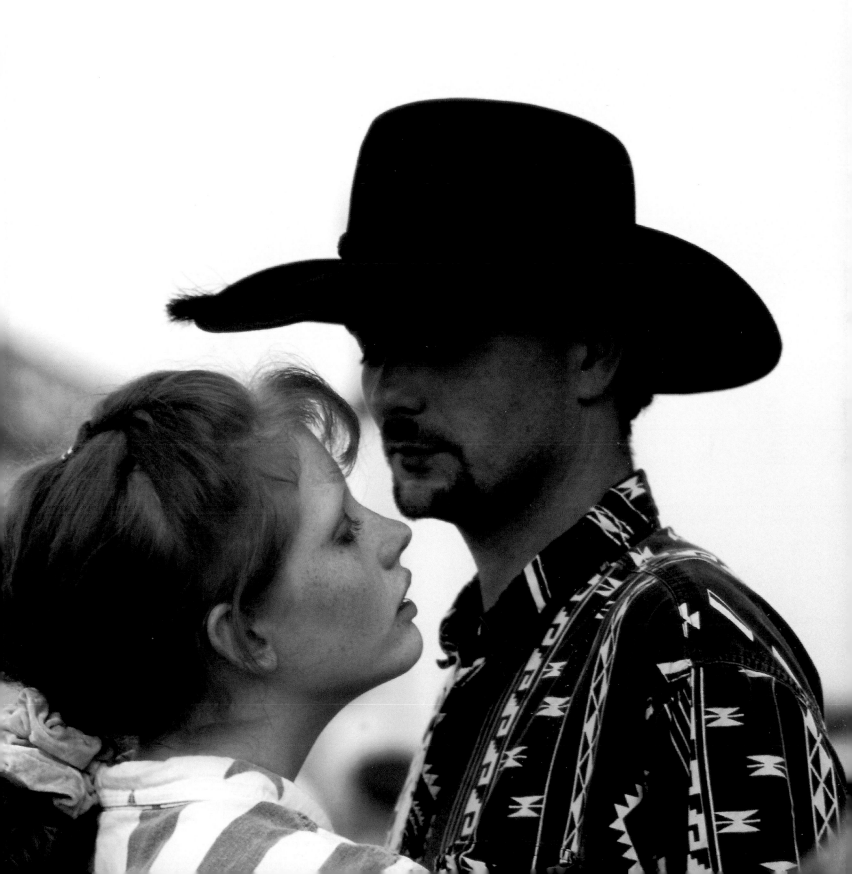

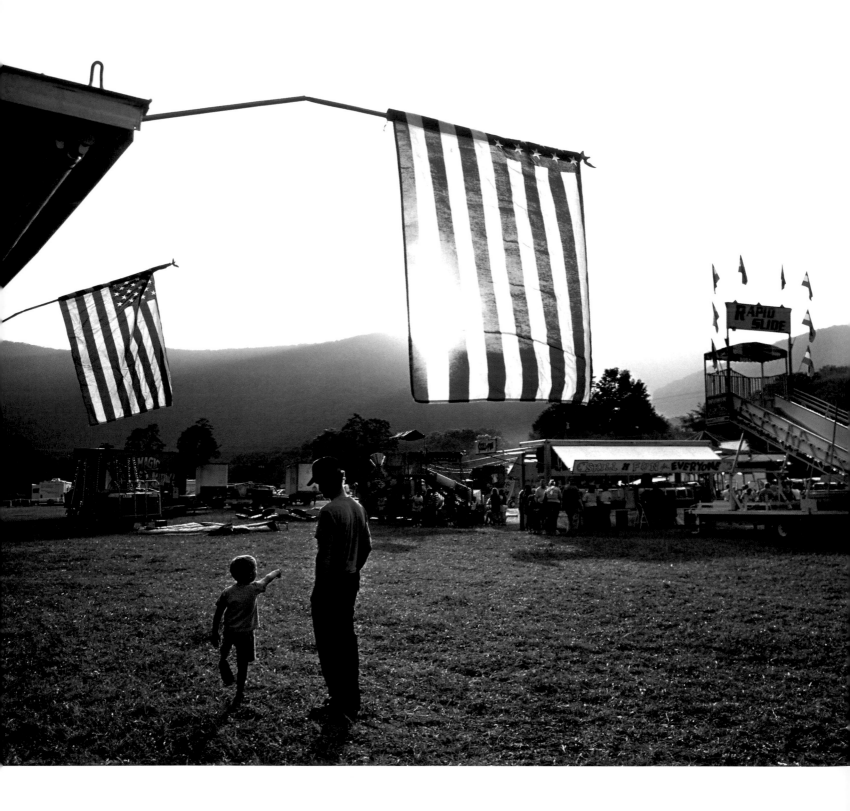

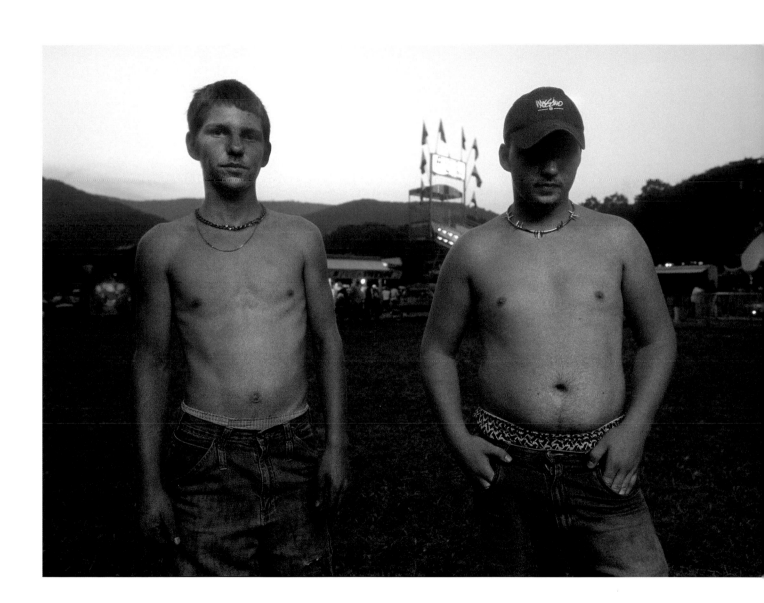

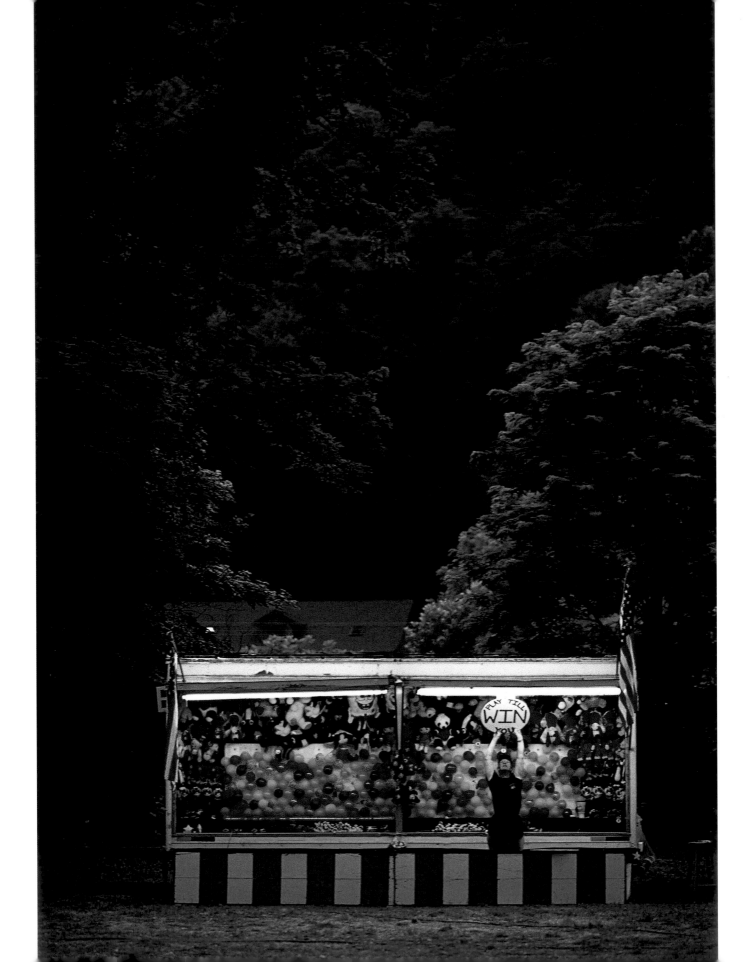

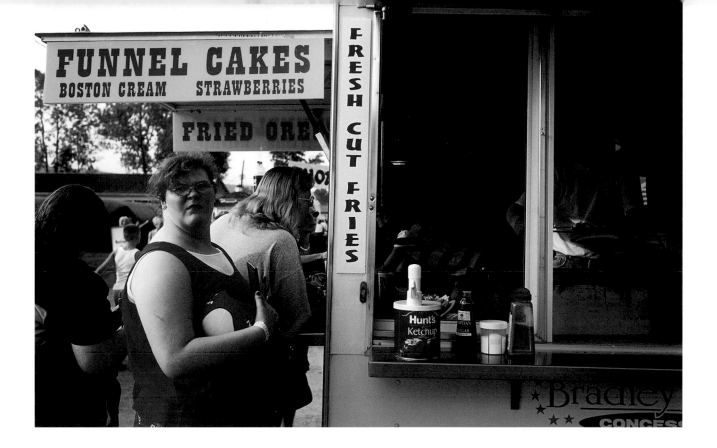

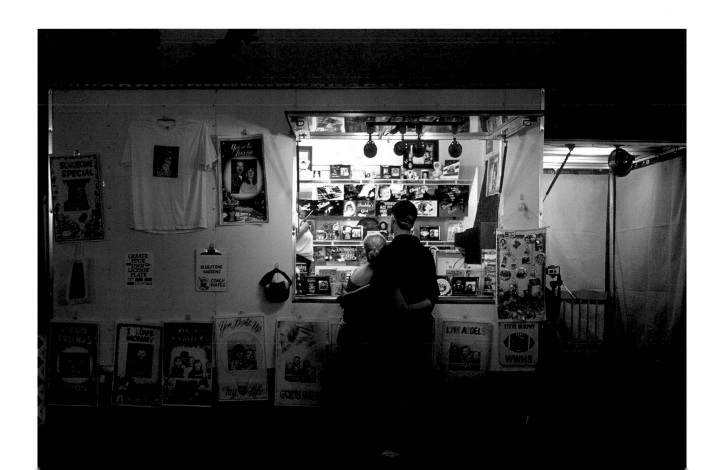

MERRY GO-ROUND

There are three pieces that make up the carnival. Merry-go-round, the 'Popper' (called that because of the popcorn it sells), the Ferris Wheel or the Big Wheel. The "Billboard of the Midway" is the Wheel. The "Key to the Midway" is the Merry-go-round, which is also called the Ginny. It was nicknamed the Ginny because before engines, mules were used to power the ride.

Kamikaze and the Zipper are the best shakers on the carnival. That Gravitron will pull everything out of your pants.

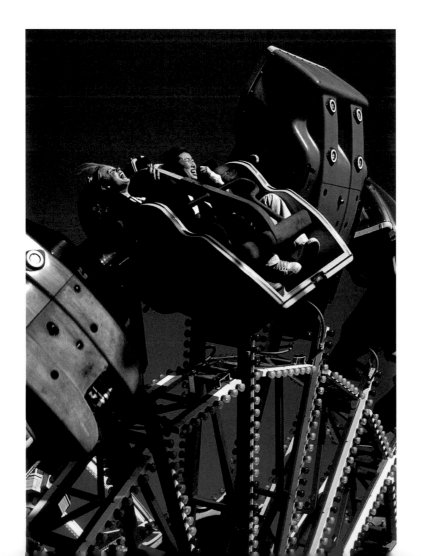

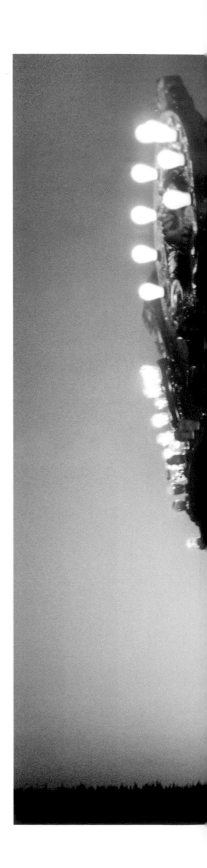

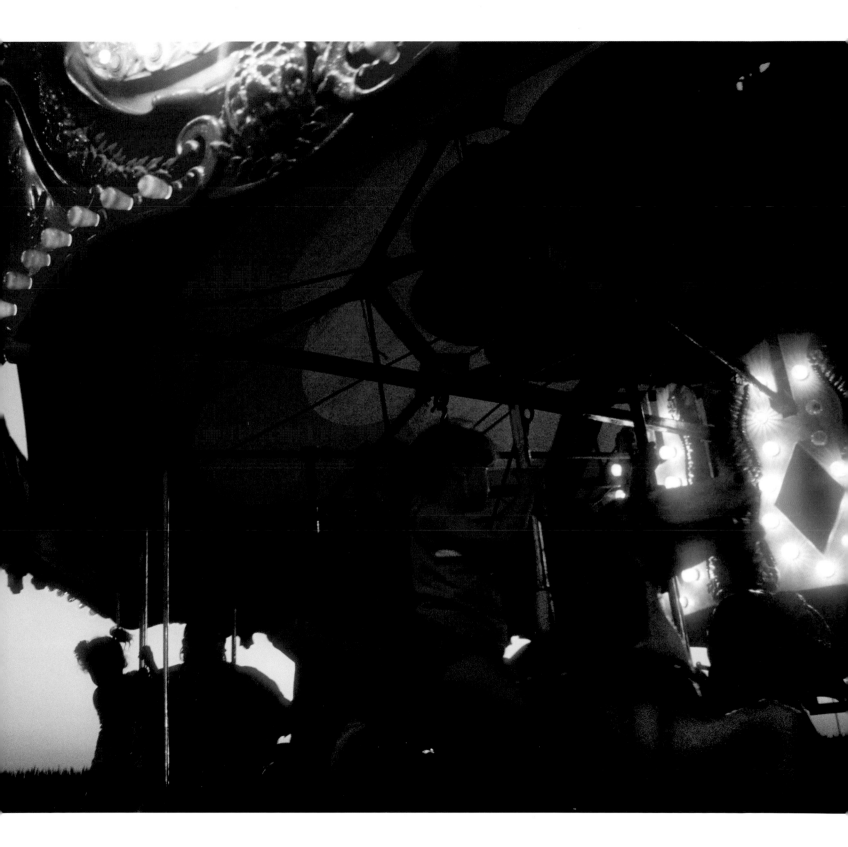

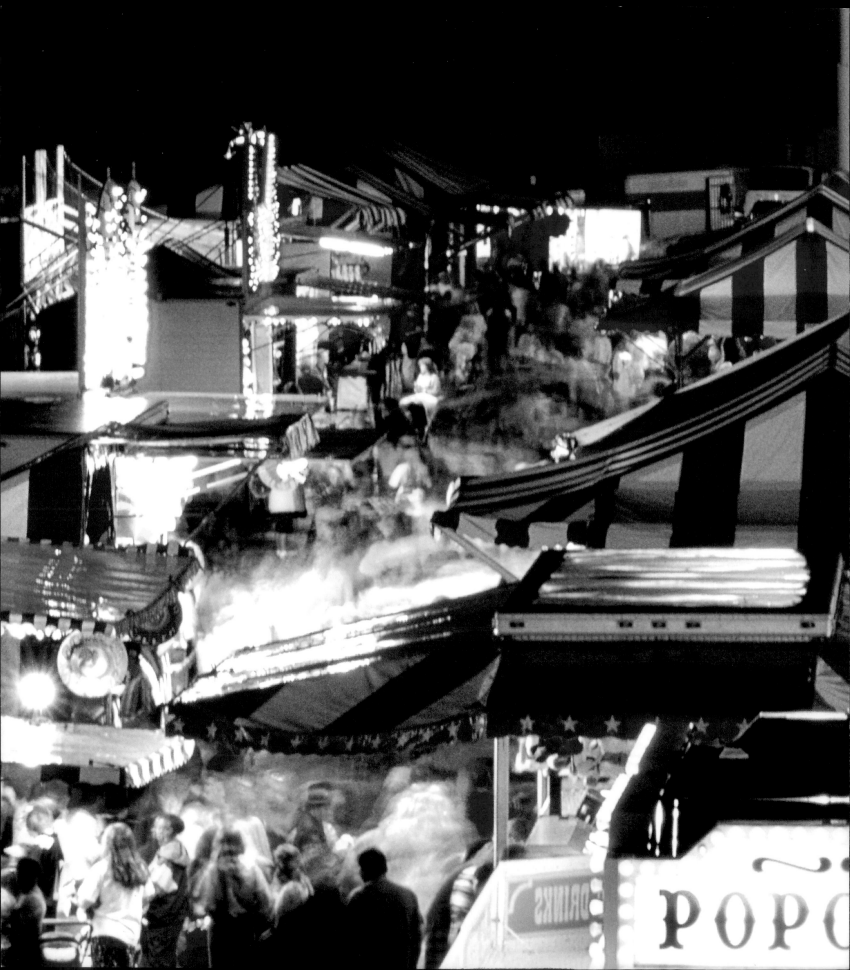

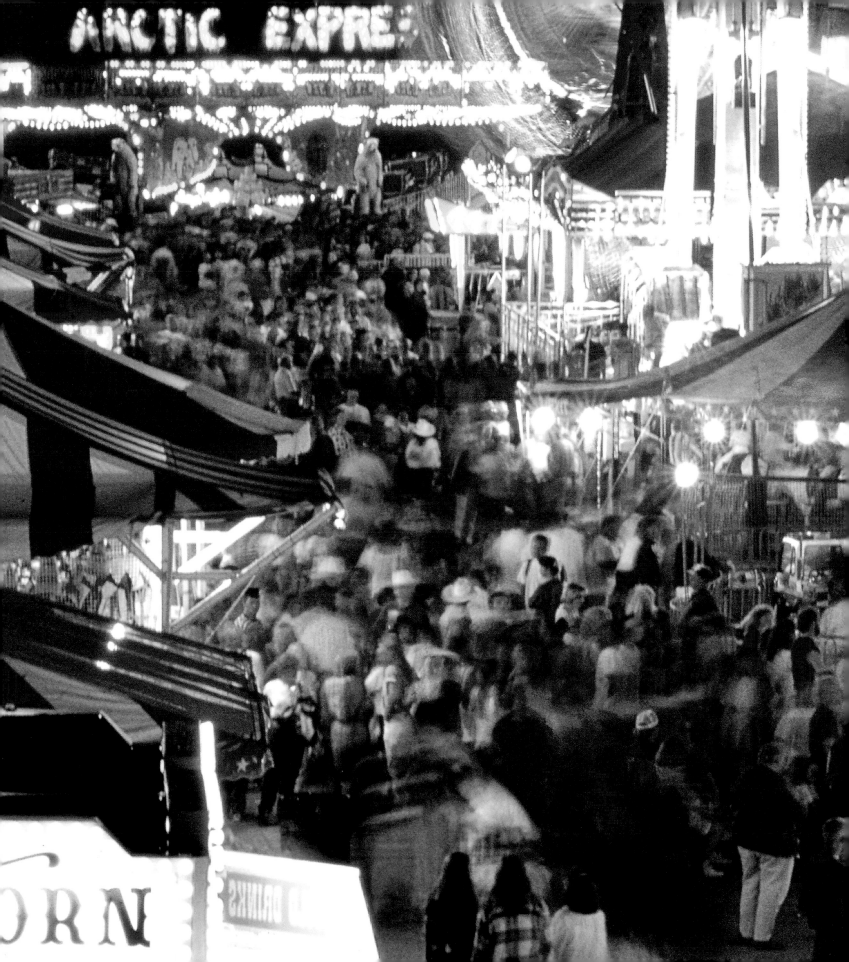

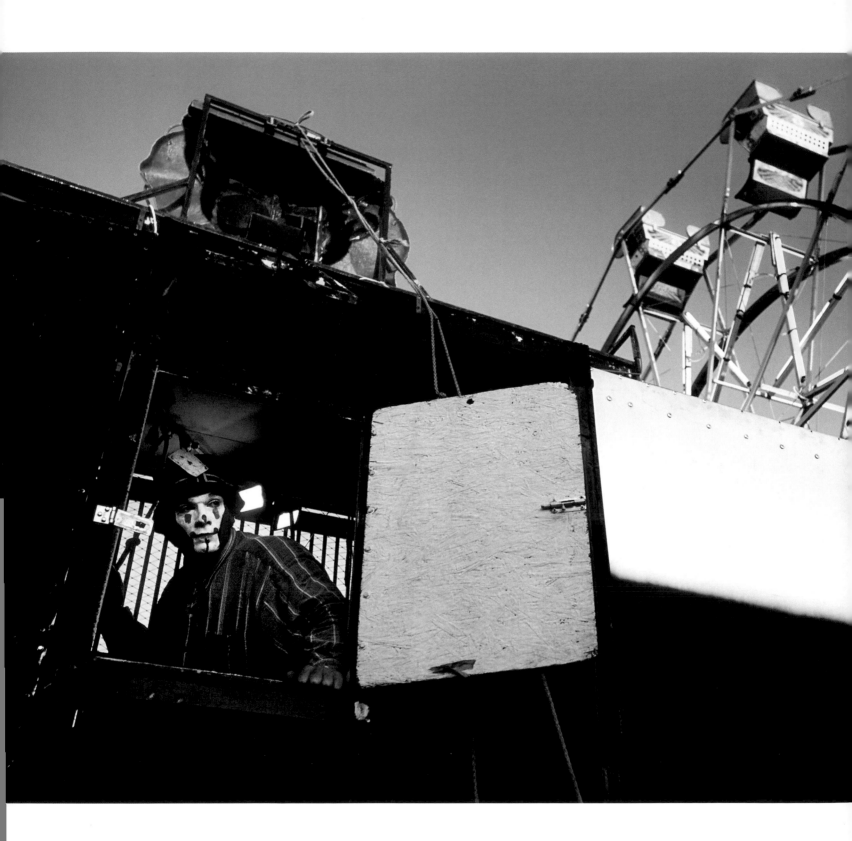

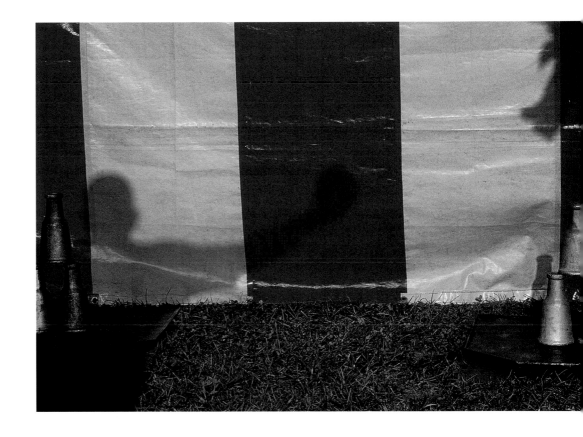

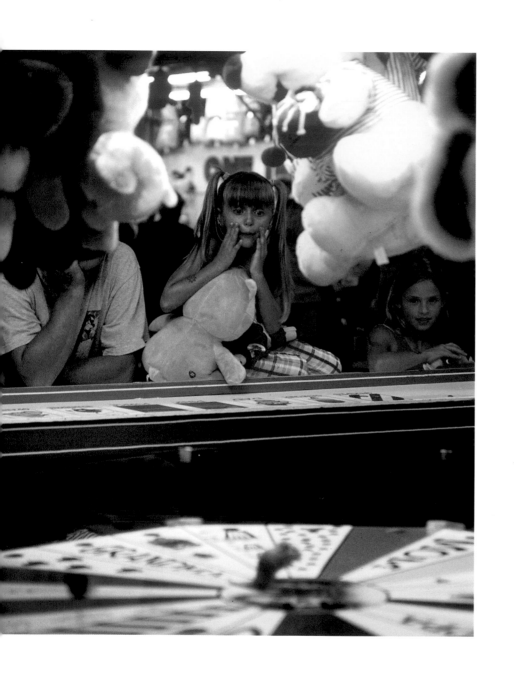
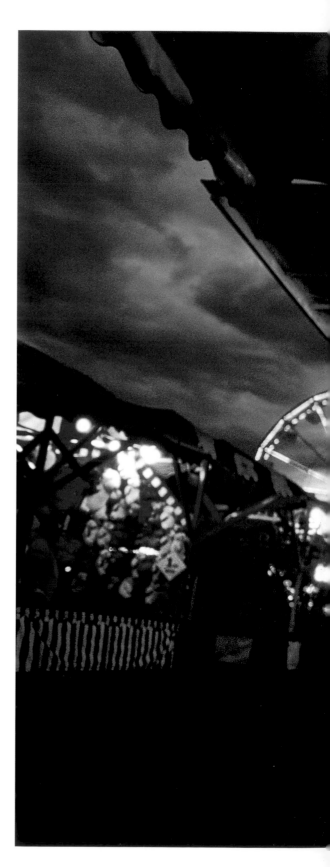

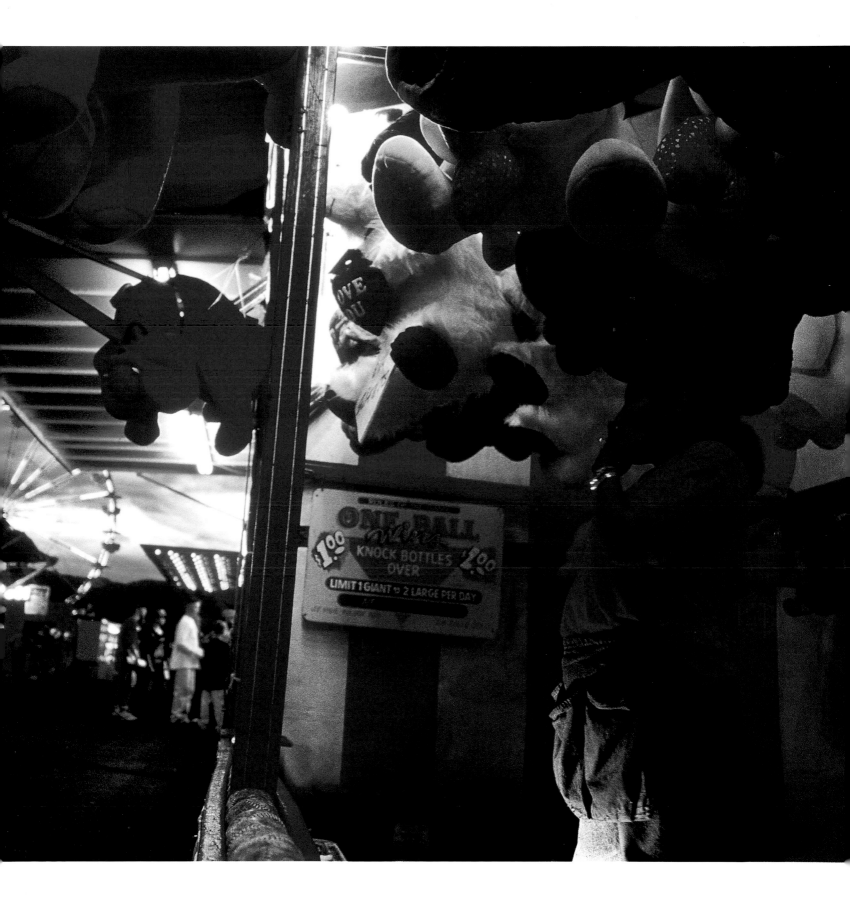

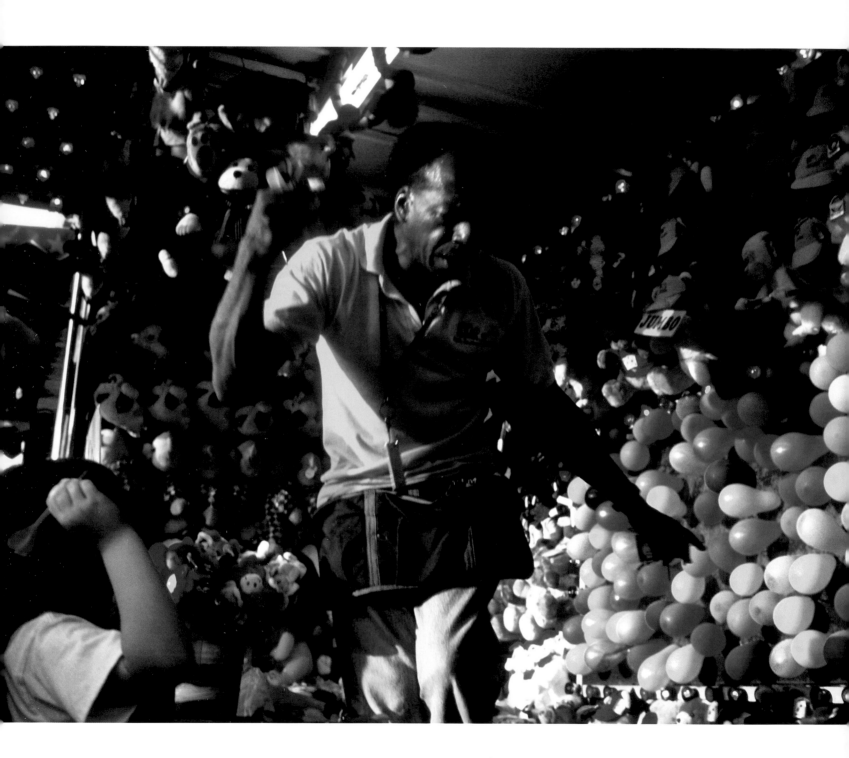

Poochie Love

First of all, if you take a person's money, you don't take all of a person's money! You limit yourself to what your top prize is, which can be something like twenty-five dollars. When you take twenty-five dollars from a person, you give them their prize and send them on, or ask them if they want to play again.

I had my start when I was twelve years old, working the nickel pitch for my uncle and cousin in Virginia. You have to throw the nickel on the plate to win a huge stuffed pig. It was kind of hard to throw the nickel on the plate, but every now and then there was someone who would throw it just right and win the pig.

When folks call me a carny, they're saying something they don't understand. I'm a showman. We are show folks—show gals, show guys, show folks—that's what we are. We're in the entertainment business. A show person is a gentleman. He's devoted and dedicated to his lifestyle. That lifestyle is whatever his occupation is, in this type of business.

And what do I do for those eight hours working? I blow balloons, and talk all day long. But I'm good at it, and I enjoy doing it. What makes me want to do this? I make good money and I make people happy.

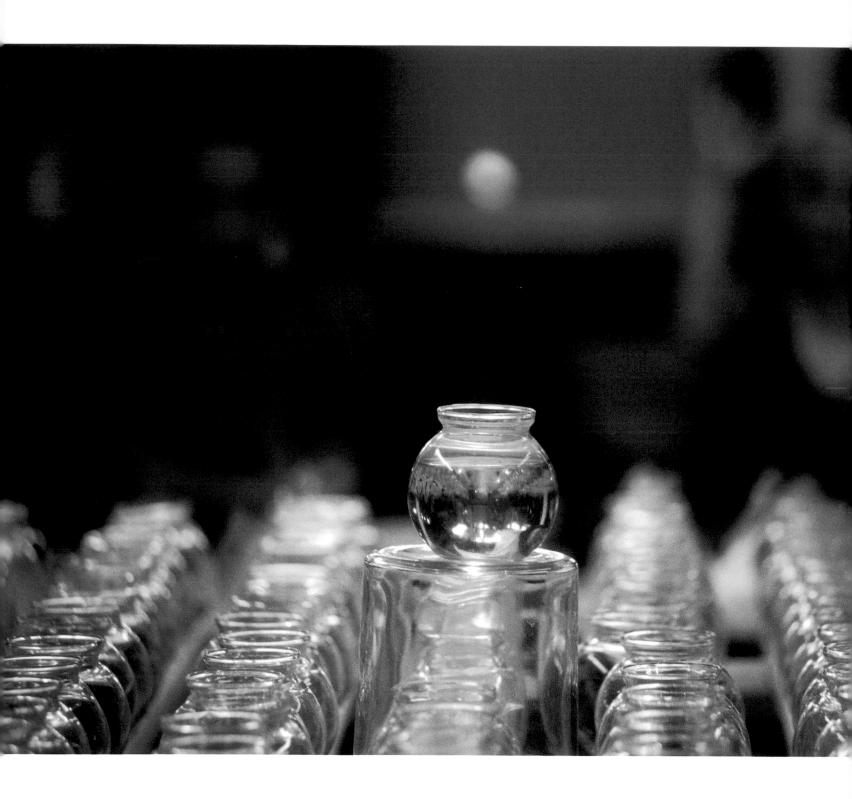

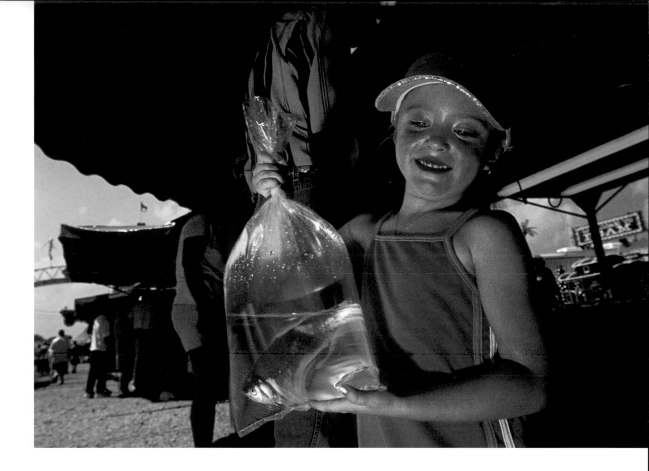
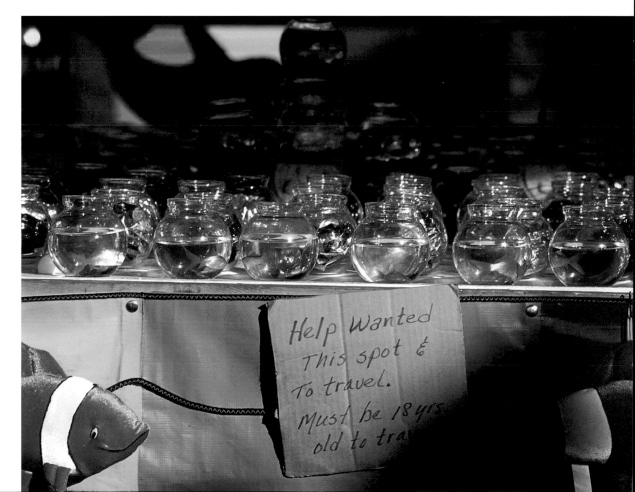

Help Wanted
This spot &
To travel.

Must be 18 yrs
old to tra

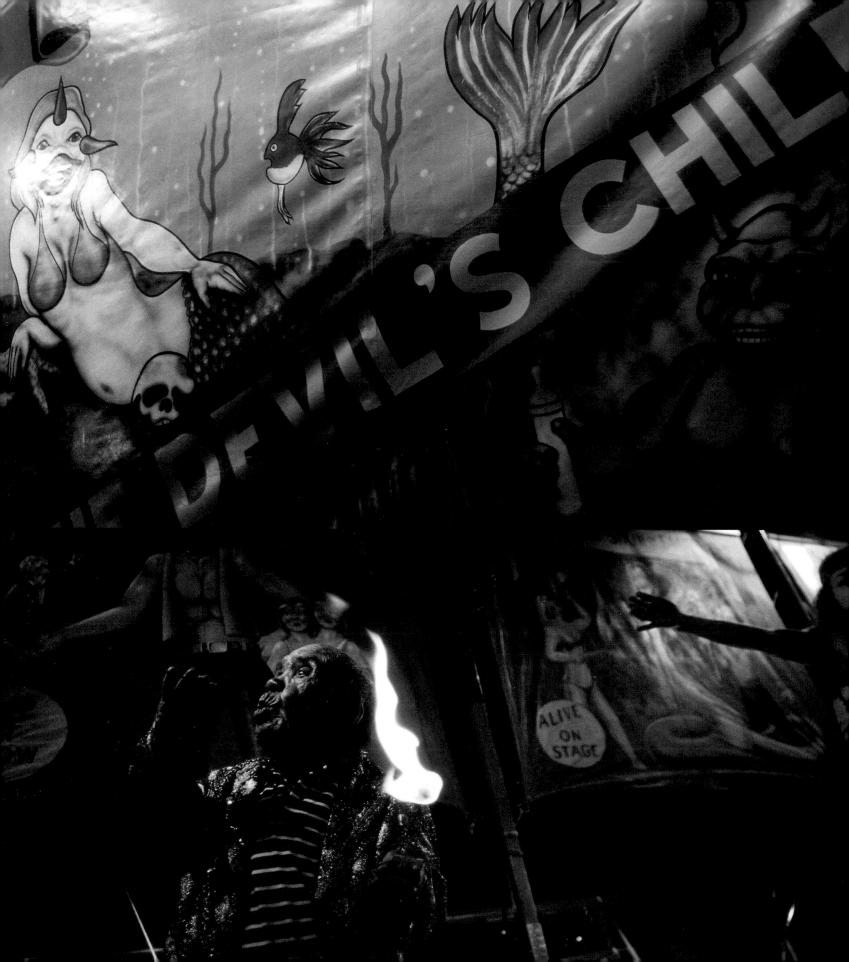

GIANT
SNAKE

ALIVE

GIANT RAT WORLD'S LARGEST RODENT

MIDGET
COW
ALIVE

INCHES
H

85 lbs
ALIVE

MINIATURE HORSE ★

DOG

1
HEAD
2
BODIES

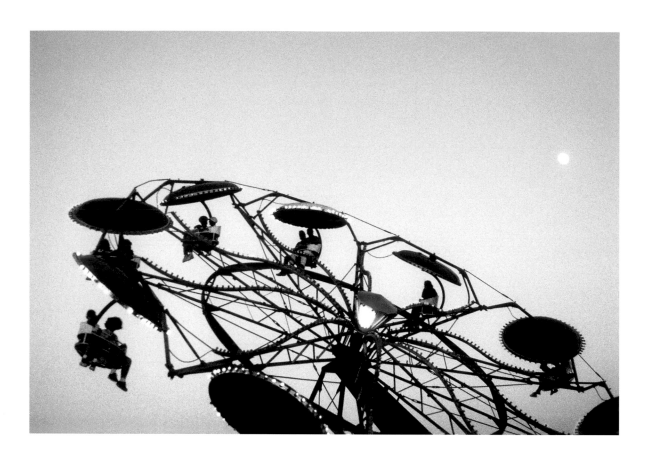

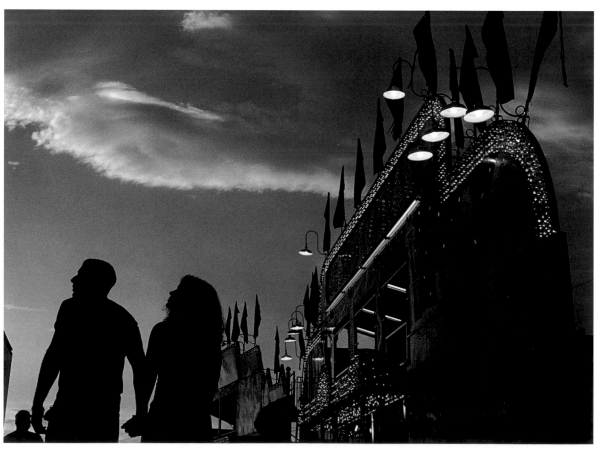

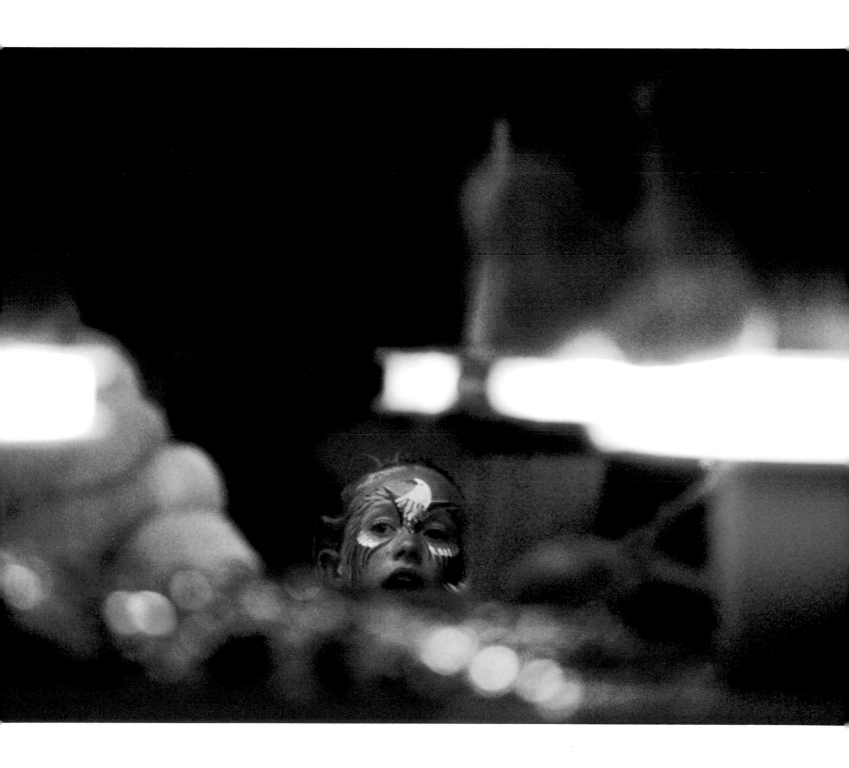

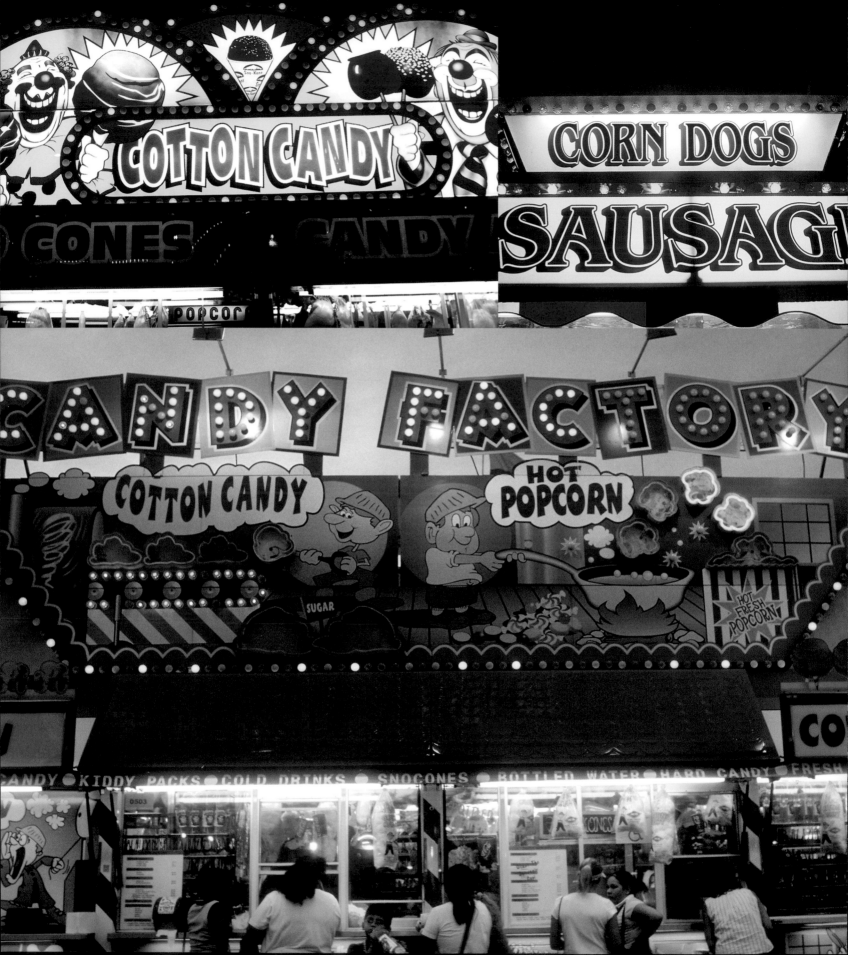

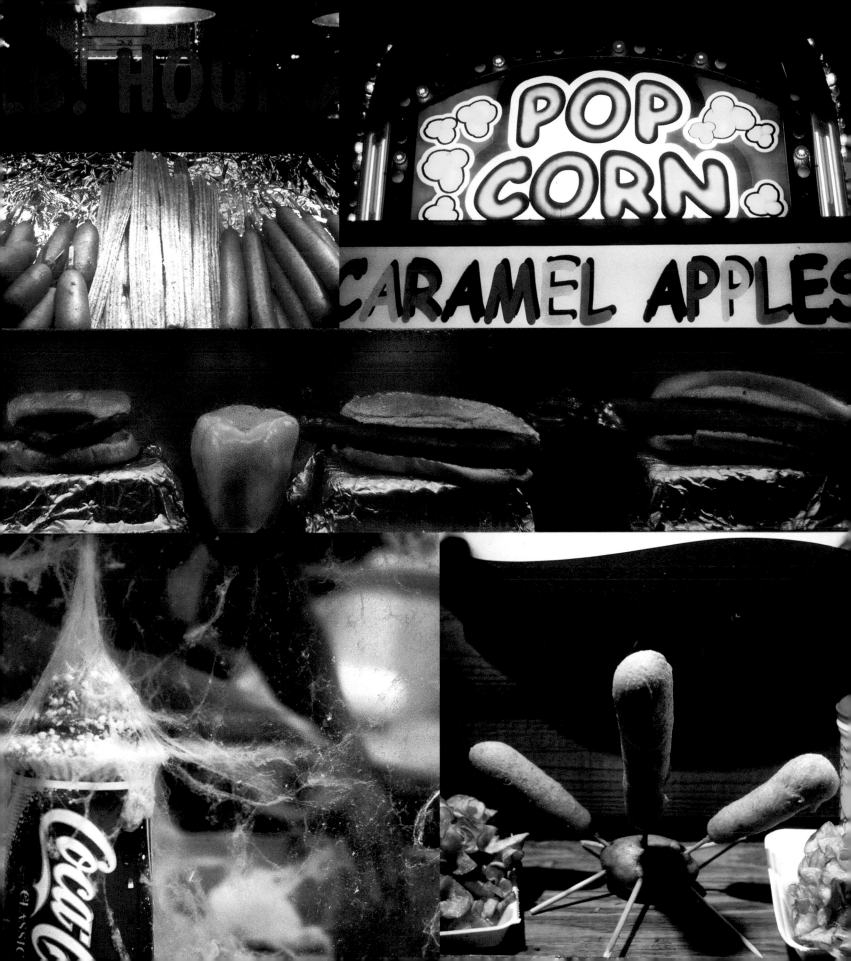

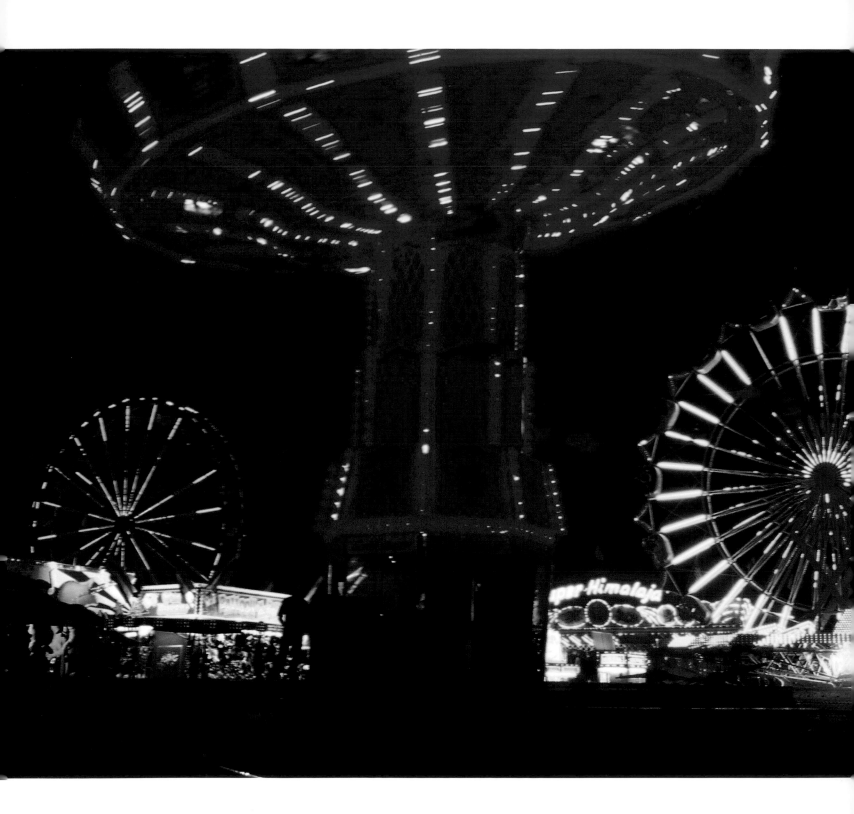

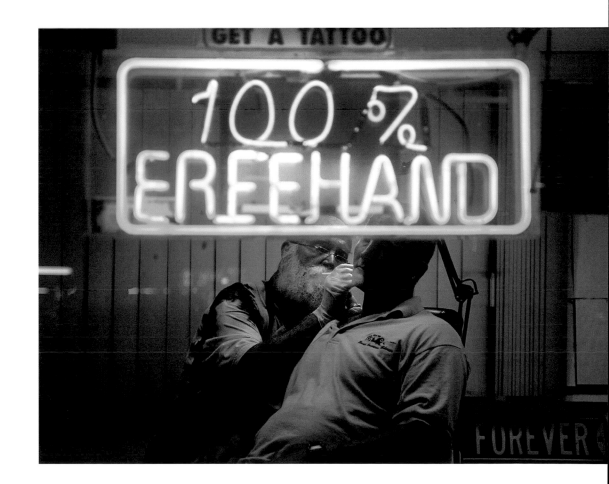

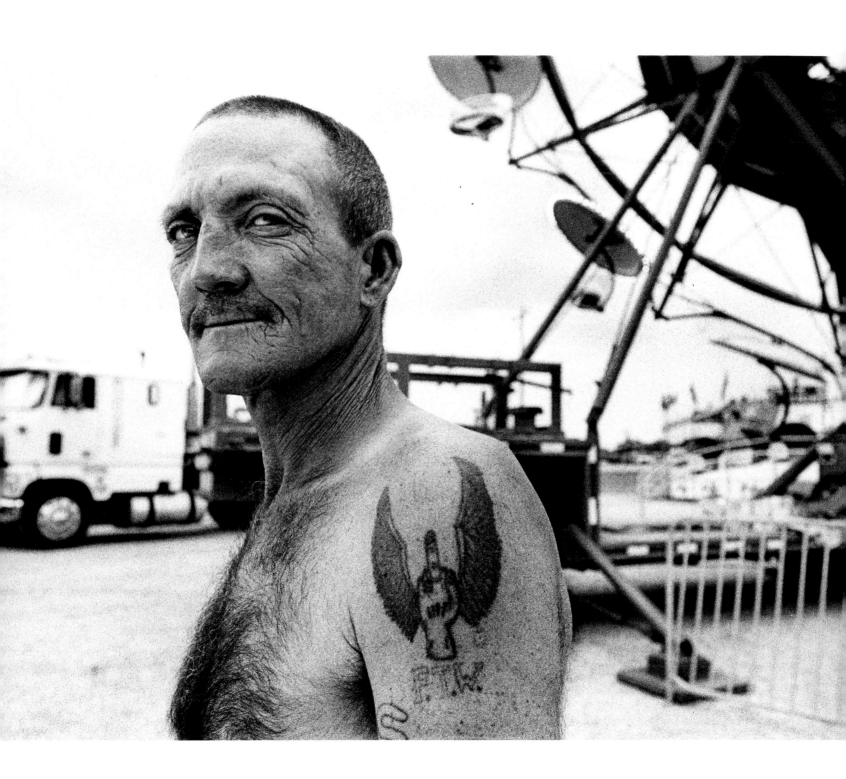

WALTER, RIDE JOCK

I've rode trains. Been in the penitentiary for five years. You can't tell me nothing, show me nothing, I ain't already seen. I've been there, done it, and I ain't afraid to do it again, just don't wanna do it again. I know if I don't stay on this show, I'm gonna stay in trouble. The carnival keeps me outta trouble. I know the way I am. I know the way I was brought up. I know the things I've been through.

This tattoo F.T.W. means Fuck the World. I got the tattoos, "love" and "hate" on my knuckles when I was fourteen. I was a lover one moment, then a hater the next.

The past ten years I ain't talk to nobody in my whole family. A couple of years ago, I was probably six hours away from them. They never knew it. "Hey man! In 6 hours I can go see my Mom." Ya know? I had to turn my head and go the other way. That's the choice me and my family makes. It hurt me.

A lot of people on this show are my family now. A lot of people on this show care a lot about me, and they know what I'm about. This place gives people security.

It used to surprise me, what I'd see when I started eight years ago. But not anymore, man! I've seen it all!

I think the craziest thing I ever seen was on a Sunday in Harvey, Louisiana, during Mardi Gras. I had a twenty-two seat swing I was running. All of a sudden I heard a gun shot. I seen a guy hit the ground. At that time it was like a herd of buffaloes comin' towards my ride. I stopped the ride and told everybody, "Don't move! Just sit!" I got me a crescent wrench and got on top of my ride and wouldn't move! Gun or no gun, I gotta protect myself and the "Man's" ride. I had pride and joy in that little swing set.

BILL & BILLY JR:

Jointy and his son

BILLY JR: I've been on the road almost since I was born. My mom walked out the door drunk on me when I was three months old. But ya know what's good? She didn't walk out on me when I was three years old, otherwise I would miss her.

BILL: I was on welfare up in Oregon. I worked on shows so I could get off welfare. Billy stayed back with friends most the time. He was about two. It was hard. I would take him out for short stays and we'd stay in motels. I would have someone watch him while I went off to work. I can't think of doing anything else and making a living, but its not like I get rich out here. I like the independence. If I don't like my boss I can just leave and go to another show and get another job. This business you have to jump around to make any money. If you're smart, you just go to the good spots.

BILLY JR: I made thirty bucks 'go-fering' for two hours. I run for cokes and coffee for the carnies. They give me the money and I go get them what they want. Then they give me a tip, a dollar, or fifty cents, some times just a quarter. I got competition though. It's a kid who's causing me problems at this spot. We were friends but we became enemies.

BILL: I didn't want to bring Billy out here for a lot of reasons. It feels like he has to grow up too fast out here. But maybe not. There are pros and cons to it. A kid learns a lot out here. You learn a lot of things out here that you can use later in life. You learn about people, you learn a lot about money.

BILLY JR: And you learn a lot about how drugs can affect your life too. Because Chuck just died. He smoked a lot and then he got cancer. I had a lot of kids on the other shows offer me cigarettes. There are a lot of bad influences out here, but then there's a lot of bad influences in schools too.

BILL: I don't want to bring him out. I just want to leave him back in a family situation.

BILLY JR: I don't like being in a family situation! I like traveling around. It's the only way I like to live.

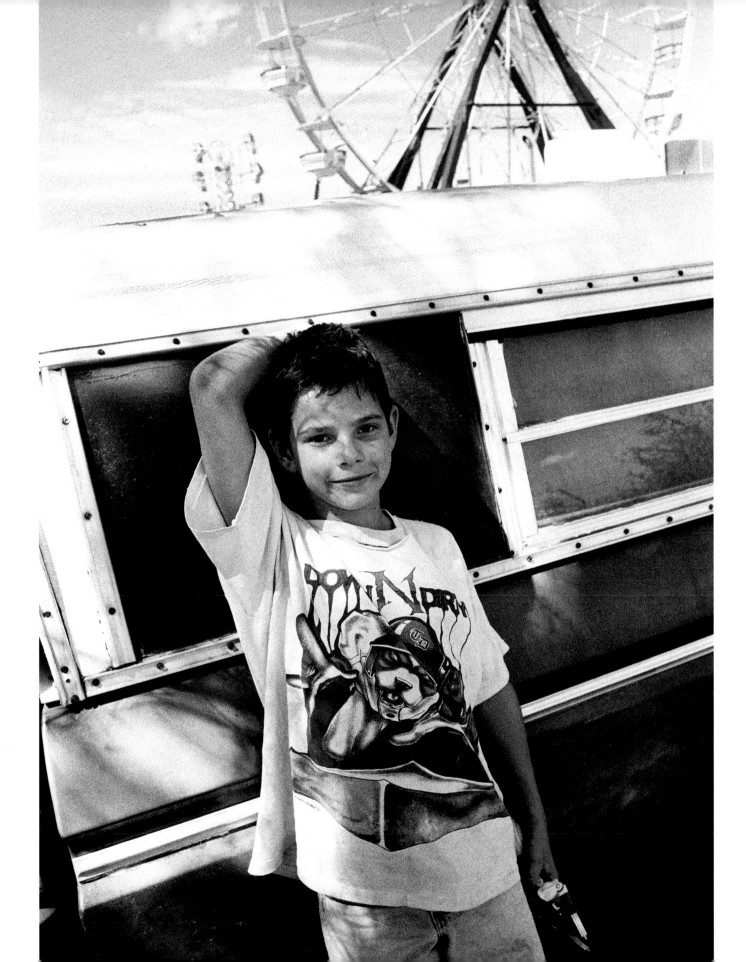

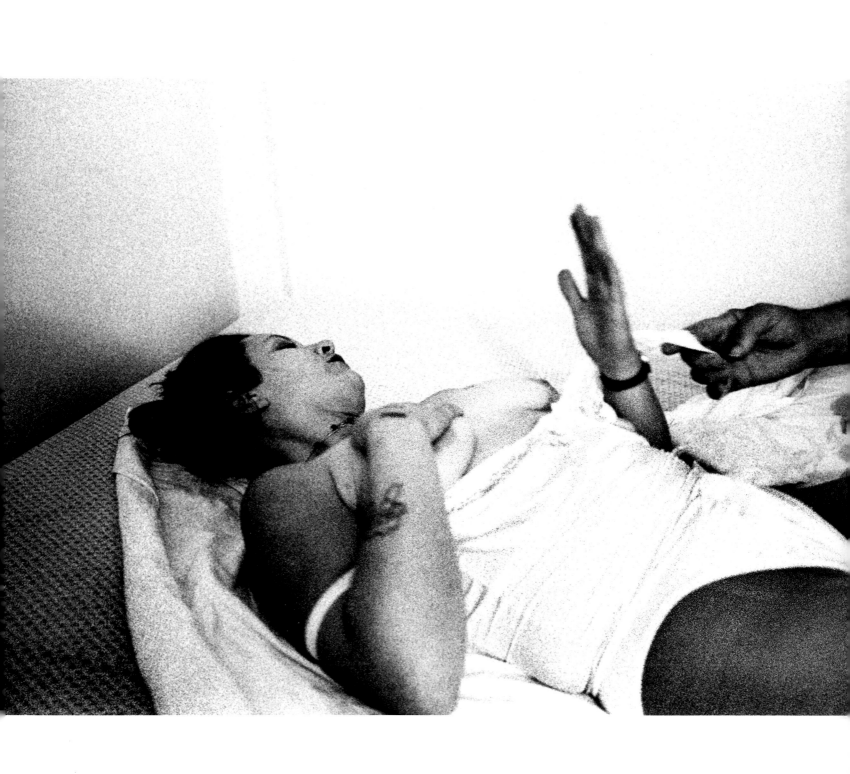

Melinda

When I do drugs I'm considered a whore who doesn't know and doesn't care. It's not that way.
I hooked up with a carnival show near Reno. I met Todd who was a jointy boss there. I got yelled
at by Mack, the owner for having fun [sex] on the ride.

I got drunk and flirting and ended up with Charles and went to Colorado. I picked him up from Libby
but left him first for a guy from Libby. I was doing Hadcs' old man while she was doing Charles after
I brought him back, after Jeff left, then Todd said, "Come here." This is where I'm at. He said he
won't take Charles back but will suffer the consequences if I showed up and the willingness to do his
old lady. It's a big long story.

Since the first time I can remember I said no. My Grandpa sheltered me. He was the only one I
confided in and he promised to keep it a secret. My Grandpa started getting sick when I was seven.
He died when I was eleven and I wanted to die with him. Things started changing when I started
asking questions. I left home at eleven.

I believe in God, and I believe in my Dad and I believe in the Devil and I believe in all the things that
have been published by Noble books. I believe in Life.

I just want to be able to know these people, cuz these are people that I want to be around.
I want to go to heaven with my uterus and my tubes untied—you know what I mean? If there is a
goddamn place, I want to be prepared. I'm twenty-nine. I've had so many opportunities to have a
good life and I've pushed them away.

RIDE **J**OCK

The couple of days I've been here I've learned a lot. I thought all you did on a carnival is jump on a ride. Settin' it up and tearin' it down is a lot of hard work, let me tell ya! I mean it's easy once it's set up. You know, you throw a kid on a ride—let 'em go around a couple of times—and then throw 'em off. You be trying to deal with their moms and everything.

I was surprised they got showers. A lot of bullshit to it too though. You live here all the time so the bosses think you should work all the time.

I'm young still. I'm able to goof off and might as well. Might as well have some fun while I'm young. Live it up. What better job can you have, to have fun while you're working at the same time. If I had a steady job, to reach my goals, it wouldn't be in the carnival.

I got two daughters of my own. I was married before, married to the same woman twice. I got married to get out of the house.

J.R.

Who else you know that can stand out in heat over 100 degrees for twelve, fourteen hours, then party all night, and get up and do that same twelve, fourteen hours again, then tear down all night and drive 500 miles and set this stuff right back up again?

We are like an American nomadic tribe. And we make all the kids smile!

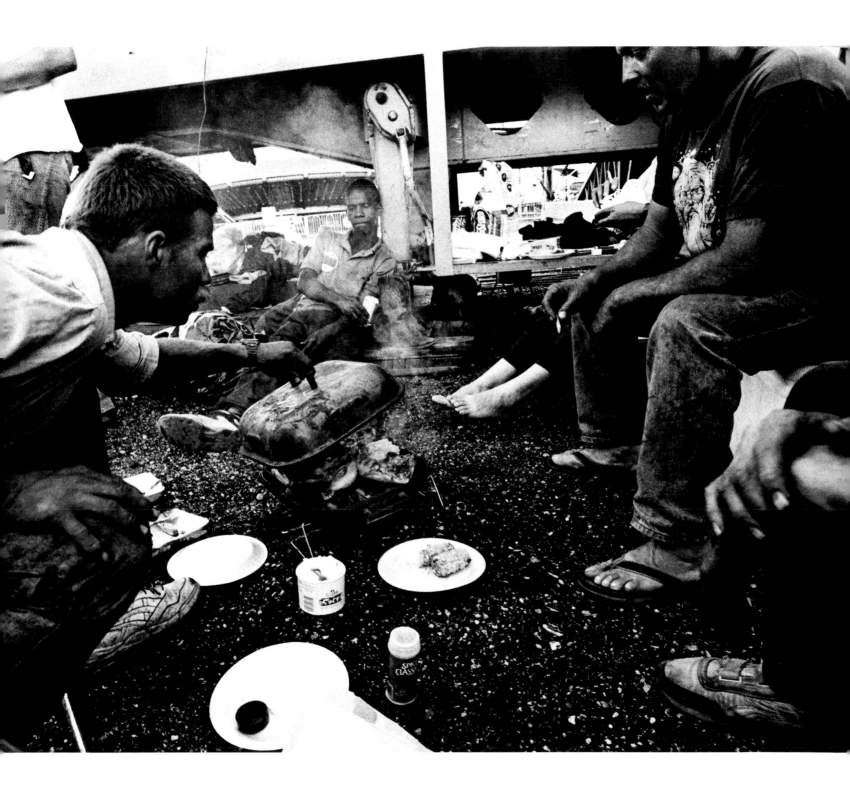

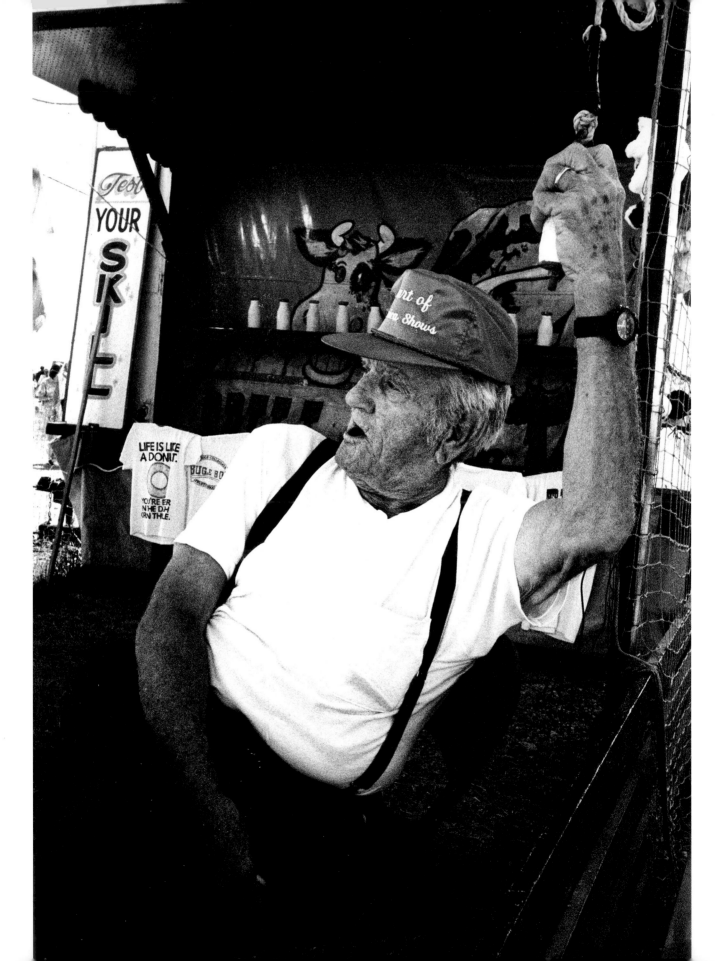

GRAMPA HACK

"Three darts for a dollar! Normally it's two darts for a dollar, but tonight I'm gonna give you three darts for a dollar. You know how to throw them darts. Tell ya what, I got four darts for ya for the first customer."

Gotta break the ice. To "break the ice" is to make your first dollar of a night. I don't think I'm gonna break the ice tonight though.

"Hey girl lookie here! Don't pass us by! Give the ol' darts a try! "Hit 'em high hit low hit them in the middle and over they go!"

Long time ago before you went by trucks, you went by rail. You'd have to tear down and wait for the wagon to come, then load up and take it down to the rails and then unload then load up in the baggage car.

My family was in the business. I stayed in the business cuz I just liked it.

I remember the first year my wife and I was married, in '37. We hadn't been married but a couple of months and she had an aunt and uncle that lived in Denver. We went out to visit. He was head of the Lance Laundry out there. He put us to work in the laundry. We had good jobs. Back then, the pay was good. We had a good apartment and across the street was the theater and you could go to the movies for a dime. One day we said we weren't gonna go back out on the road. Her uncle was gonna advance us in the laundry business and we said, "We got it

made!" So that went on all winter. In March we went to the movie and they had a carnival scene with a merry-go-round going around and we heard the music and we jumped up and said "They're opening in Ellsworth, Kansas, Saturday! We're on our way!" Heh Heh Heh! Man, we couldn't pack fast enough to get on our way.

So after that, never did hanker for no regular job. I've had a lot of jobs when we were off the road and that helps me out. Because a lot of times when we're not doing too good on the games and I have only a fifteen or twenty dollar night. I git to thinking about them odd jobs I used to have—I used to work nine hours for nine dollars. So I always think to myself, "If I had a twenty-five dollar night, that's twenty-five hours I'm working. HeHeHe...

I don't want to get out of the business. If it gets into your blood, it stays there. I do get out the business in the winter time. I go fishing.

"Three balls for a dollar! Hit 'em high! Hit 'em low! Hit 'em in the middle and down they go!" "Hey, Hey, what you say! Here's where you play ball today! Play a ball stay a while! Heh! Don't be shy let them balls fly, fly, fly! Play ball at my house! A whole lotta fun for a little bit o 'mon! Come win you one! Come win a cadoddy!"

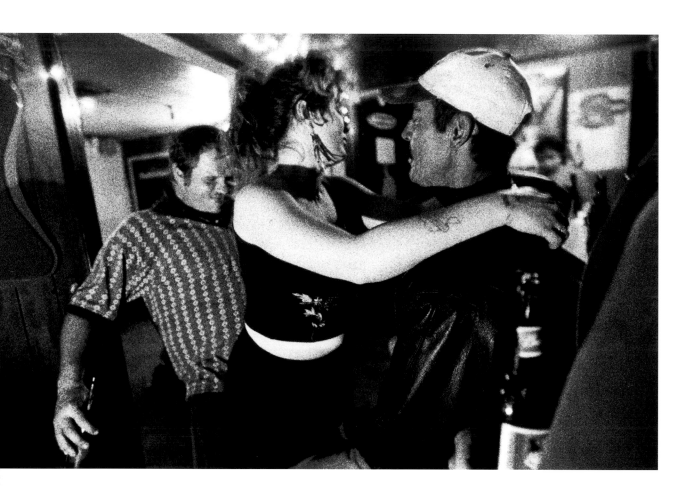

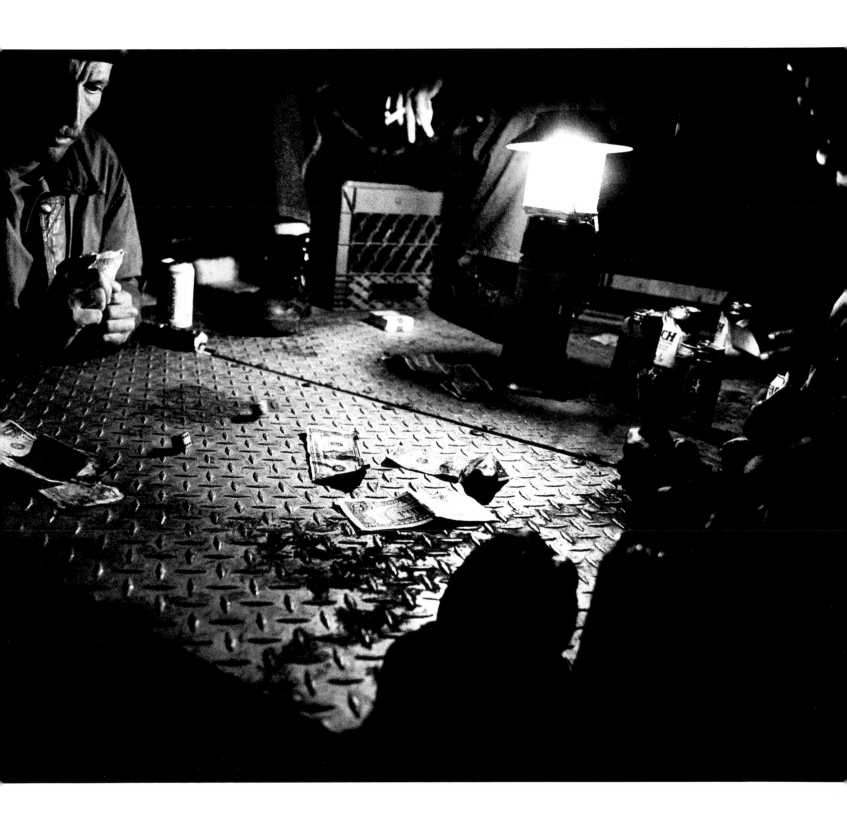

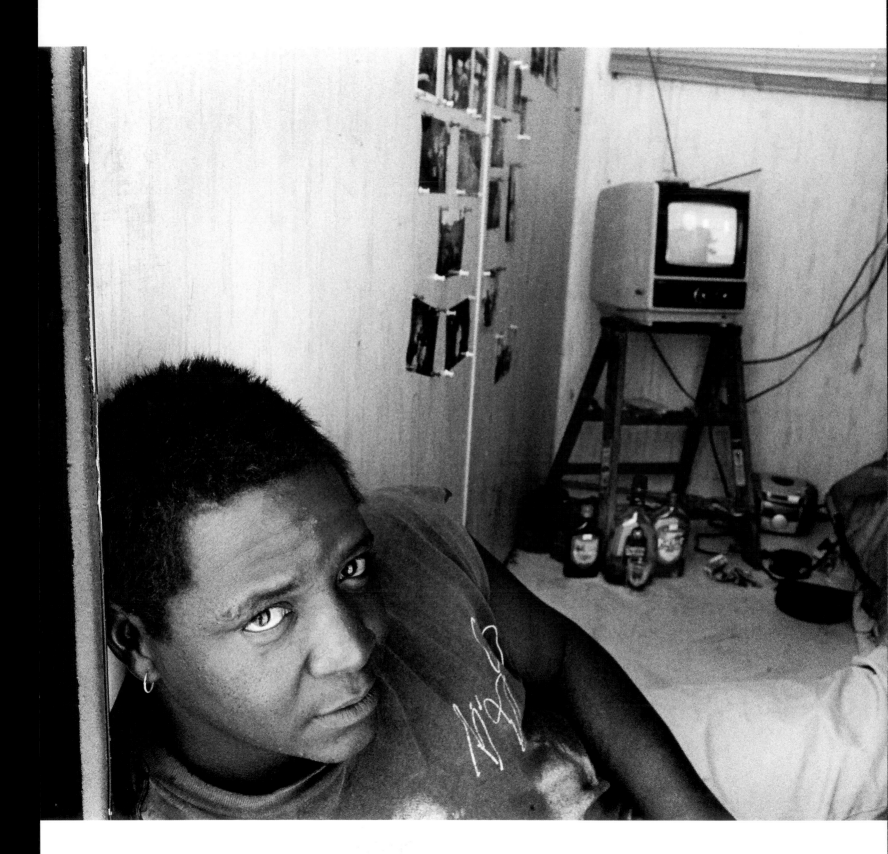

MAGIEK

When I came to work out here, a guy said to me: "The less people know about you the better off you are." So I started going by 'Magiek'. I've been out here thirteen years. I am a ride jock, but I've been a jointy on other shows.

I had a real good job, but I had inhaled some chemicals and got sick. I lost my job, and my wife took off with my son. Just everything was going bad. The carnival came into town and I said, "Why not?"

It's addictive out here. It's hard to get it out of your system, even if you just work a little while. It's worse than any drug I know.

Only about ten of us go somewhere at the end of the season. But for the rest, they don't have nowhere else to go. This is all they got.

My real family don't like it when I'm out here. My people aren't racist but they'll always ask me, "Aren't you scared going all them miles away with them white people?"

For a long time I was the only black out here, but I've never have had problems. Every now and then you get some new people out here who want to try me, but I can handle my business pretty good. I ain't lost a fight out here on this show. Once on the last show, but I was fightin' two people. I was doing pretty good, but I don't have no eyes in the back of my head. They just call me Magiek but that's about it.

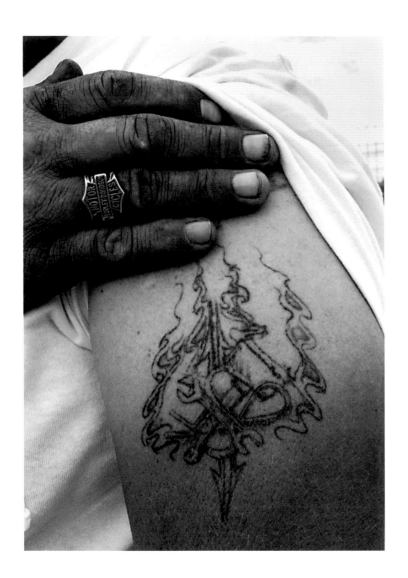

RIDE JOCK TATTOO

The ride jock emblem—the hammer, the wrench, and the dollar sign. Its what we out here symbolize.

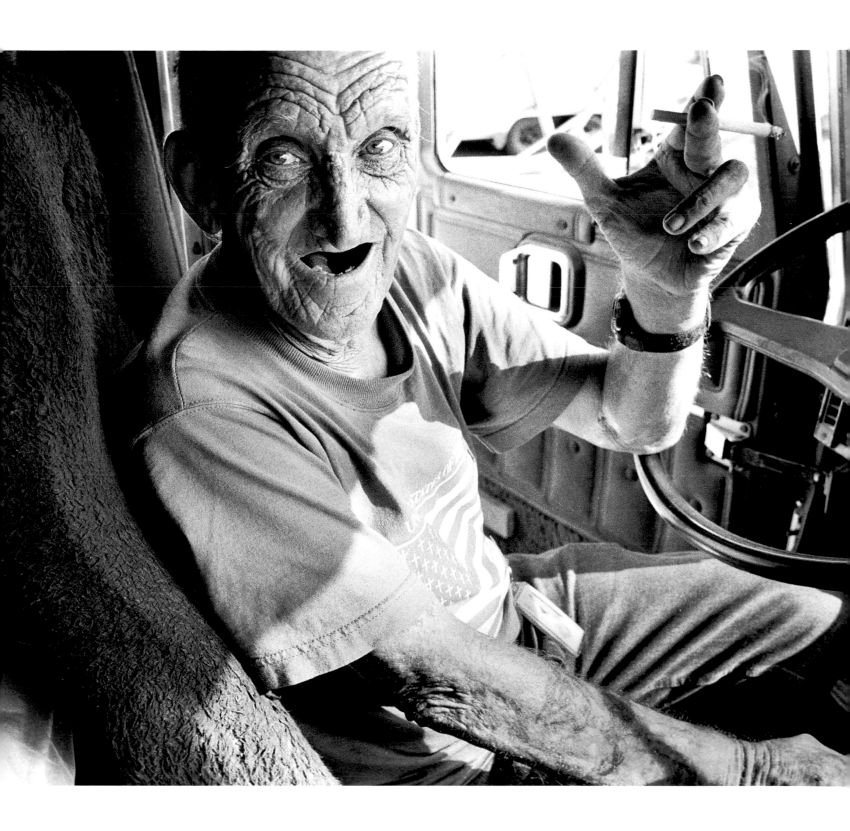

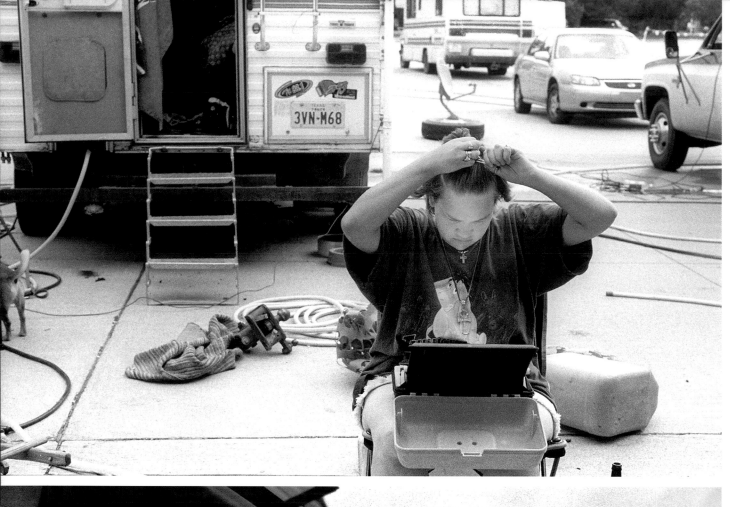

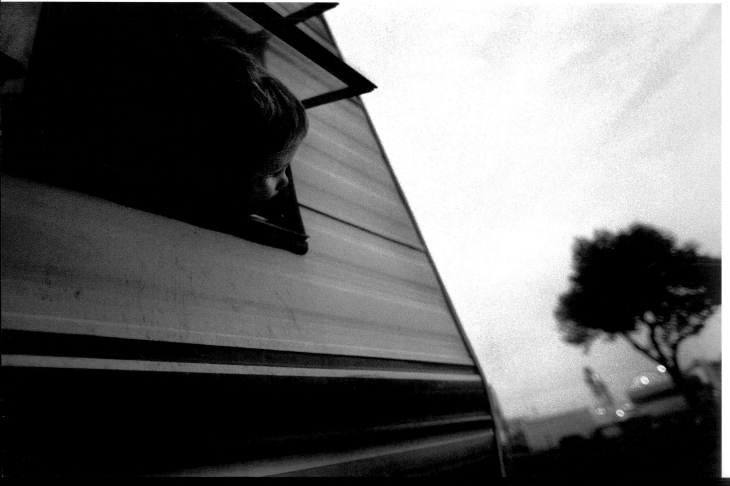

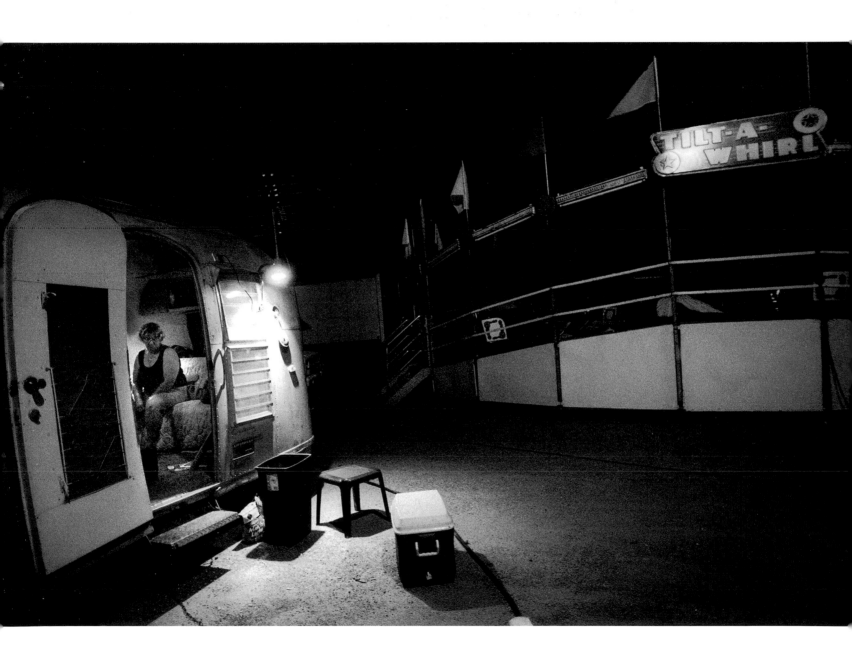

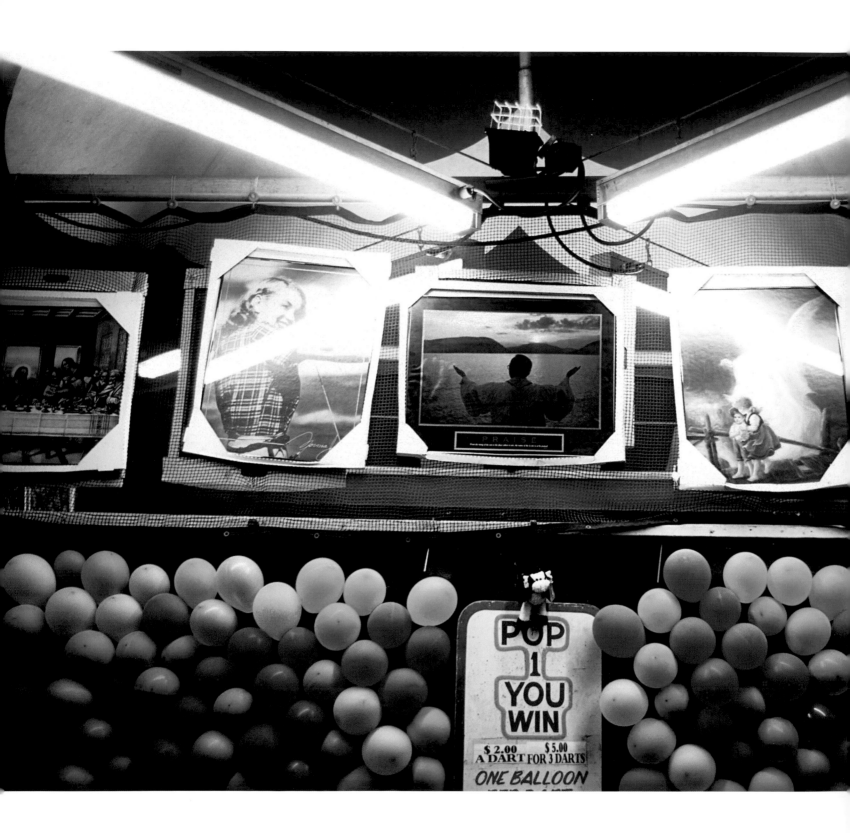

PRAISE

POP
1
YOU
WIN

$2.00 $5.00
A DART FOR 3 DARTS
ONE BALLOON

HAIRY:
Popcorn & Cotton Candy maker

I like working in my popcorn trailer. I've got a cotton candy ceiling! From my popper I see the midway, and the miles of smiles!

I told someone before I came to the carnival that I just wanted to find "it". It's a really small, little word. I didn't know what "it" was, but I knew that when I found "it", I was going to be able to take a breath out and not such a big one back in. The minute I walked onto the midway to work, I felt "it". I just knew I was home. I live in a room the size of closet and it's the best room I ever lived in. I feel like I'm seven years old and want to run to the midway to work every day.

My childhood wasn't happy. My dad was an alcoholic and really mean. He never let me be a child. When I was seven, I thought everyday was a new day and it didn't matter what he did to me the day before. But then I turned eight, and I thought, "life is miserable and I will never, ever be happy."

It's like magic every week. The show comes down, we put it on trucks, travel to the next town, and rebuild our little city. It's the same city every week but with different locations. There's always a big fat lady in a wheel chair wearing a housecoat and being pushed around by her miserable kids. I love to hear townspeople talk to each other in front of the popper. For some reason with cotton candy and some fair music in the background, everyone from that town comes together for that week.

I liked the carnival when I was little. I'd stay all day long watching them set up. Then I'd listen to the agents call people in. I'd listen to them holler and say, "If you don't play my game tonight, I won't eat tonight!" I would wonder where they were the week before, and where they were going to go when they left my town. On the last day, I'd be so sad that they would be leaving. I wanted to hop into any possum belly and go down the road with them.

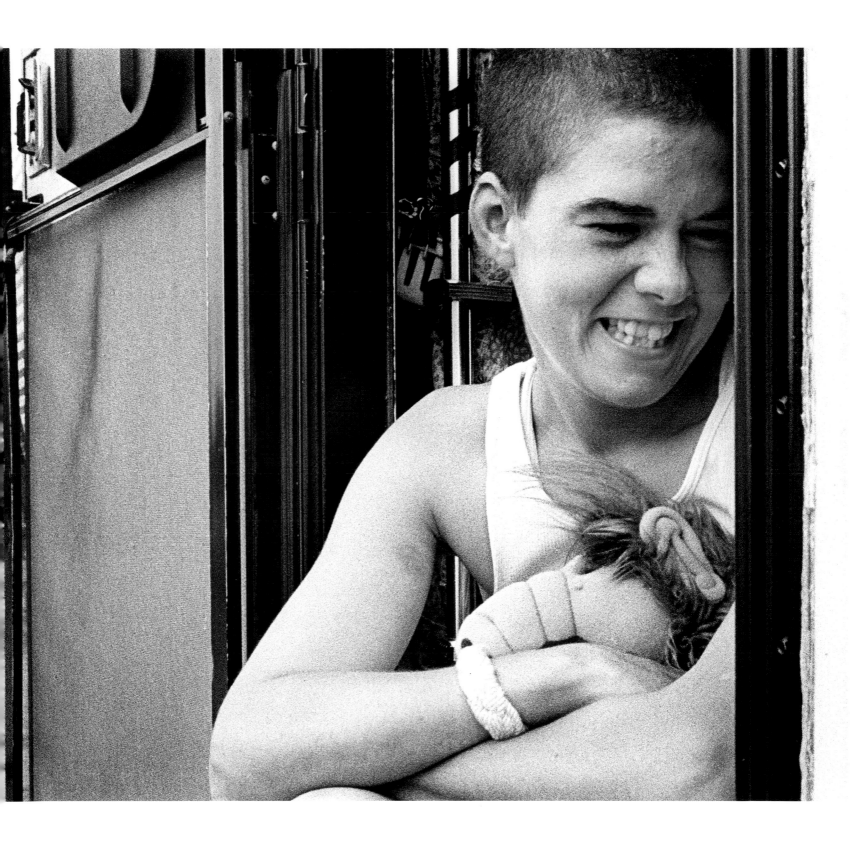

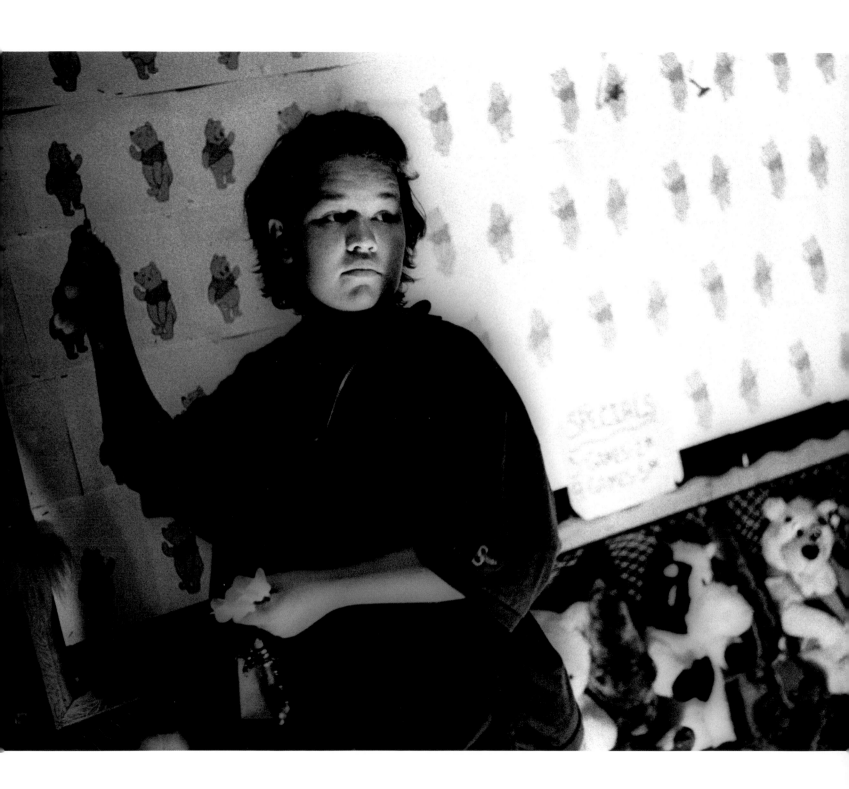

ROSE

I like the ride jocks better than the joint operators cuz I like to see them sweat. It turns me on! I work a game called 'Shoot the Pooh'. I been here a little over a week with the show. The show is my family now—and the other part of my family doesn't really care. They don't care about me. I called to tell them I was leaving and they just said—"Bye".

My three-year-old daughter died about nine months ago. Her life was taken tragically. She was murdered by my ex-husband's girlfriend. She shook her to death while striking her head up against a metal kitchen cupboard. The girlfriend is in jail right now. My other kids live in Omaha with a family. They were both adopted into the same family. I fantasize about my kids being older—not knowing I'm working the carnival and them walking up and being face to face with their own mother. That would scare me. I wouldn't be able to talk—I wouldn't even know what to say to them if they were staring straight at their mom and didn't even know they were staring straight at their mom.

After my daughter died I didn't care, all I wanted to do was drink and do drugs. I was in a depressant stage to where nothing mattered. I wanted to end my life.

In ways I am hiding from what I've gone through with the death of my daughter. I don't want to run away from life, but I wish I could run away from mine. My life would have been so different if I hadn't had kids. I wouldn't have been tied down married. I wouldn't had to go through a tragic divorce, and my daughter's death. I wouldn't have given my kids up for adoption. I would have had my "young years", instead of being a mother at a young age.

I think being out here on the show is like trying to get back my young years.

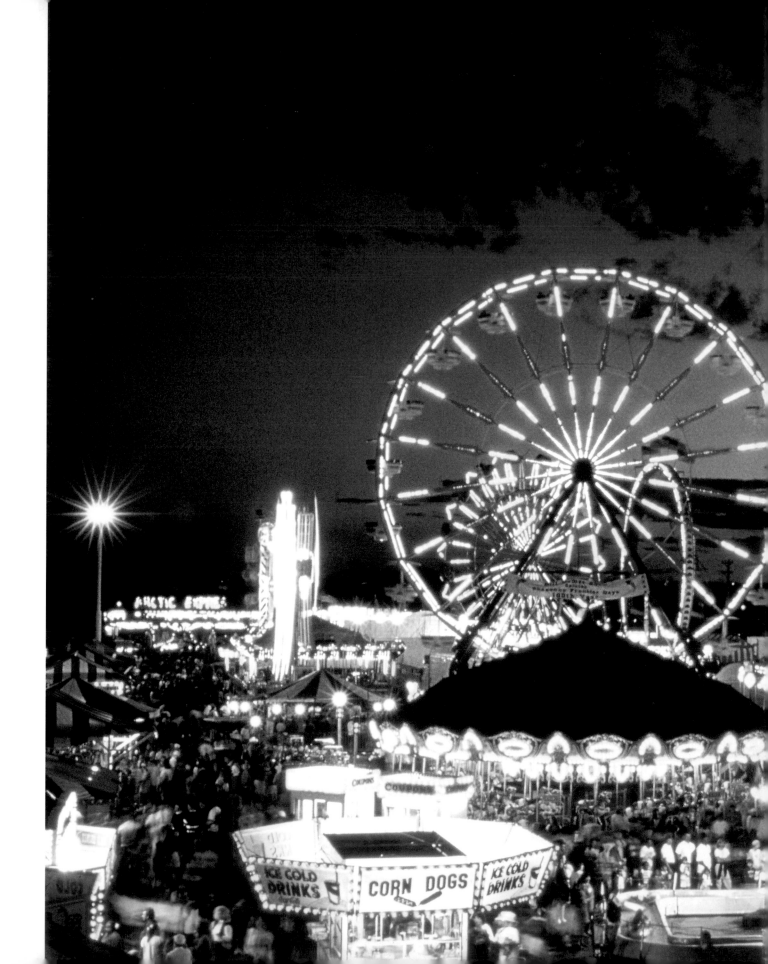

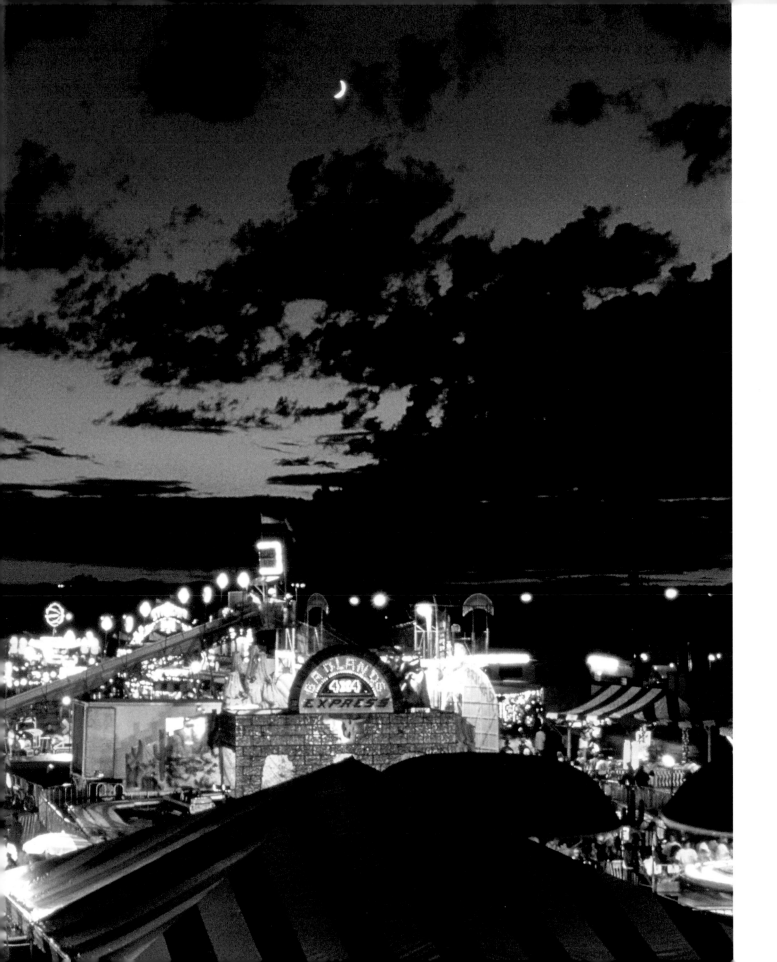

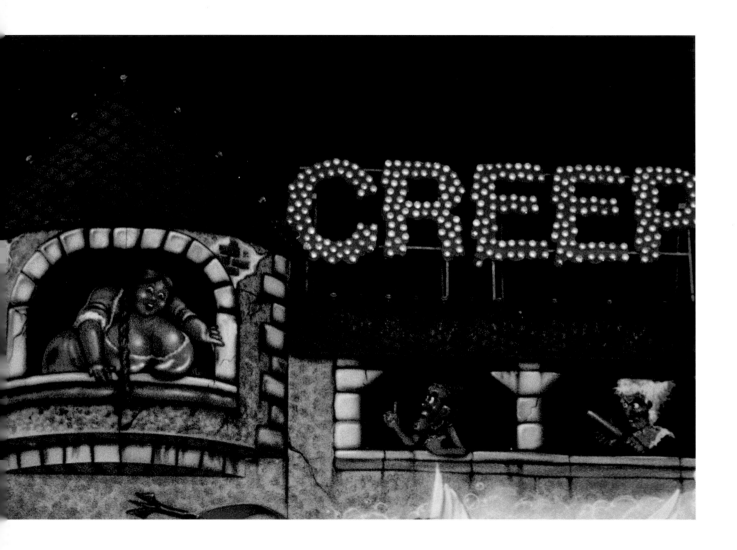

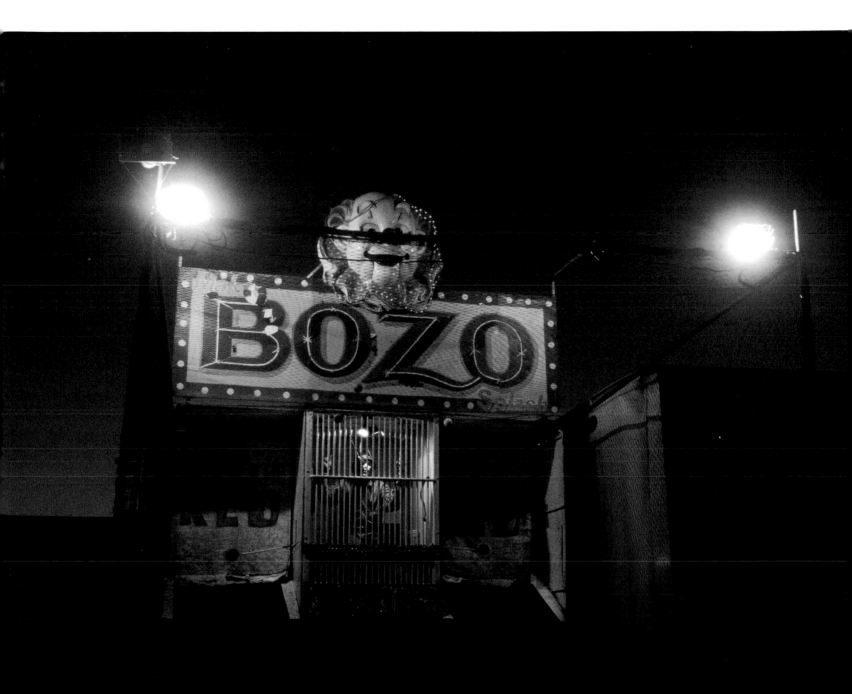

We are a professional traveling amusement company. This is our "Disney on Wheels". When both of my units are together, I have over 250 people working for me. I have certified welders, certified state inspectors, and a national inspector. We have full time mechanics, hydraulics specialists, heating and air-conditioning specialists. We have just about everything we need to make it work.

I spend a lot of money on upkeep and maintenance too. Just the ride paint bill alone is $70,000. The generator for the rides runs about twenty-seven gallons of diesel fuel an hour, and we run three or four generators for all the rides. I also run forty trucks for the jumps from one spot to the next and we move close to 100 loads every week per show unit. We have about $10 million dollars in equipment and rides. But the amount of money we spend and make is equal to the amount of people we make happy.

I'm the fourth generation of show people. My son who runs my other unit is the fifth and he has a boy who will be the sixth. My grandparents had side shows. Freaks shows. We had a two nosed dog, a dog with five legs and six paws and snakes. It was always my dream to be around equipment and have a nice carnival. I started out with three rides and now I have fifty.

Corky Powers:
Carnival Show Owner

My goal was to start a new image for the industry since the image back then was pretty poor. The lifestyle has changed completely since the days of my grandfather. We don't live in tents anymore, we live in $150,000 travel trailers with washers and dryers, and all the other conveniences you might want to have. You need to have some comfort since you're traveling thirty-four weeks a year.

We have rules and regulations on this midway. One of the rules is to give away twenty-five to thiry percent merchandise. We want to see people winning and carrying around merchandise. It's a big part of having a carnival, wanting people to play the games. Years ago, carnies used to take advantage of the townsfolk—cash their payroll checks, take their rent money, and rob them of their life savings through shady games. There may be still a carnival like that out there, but for the most part, that doesn't happen anymore. Those days are definitely gone.

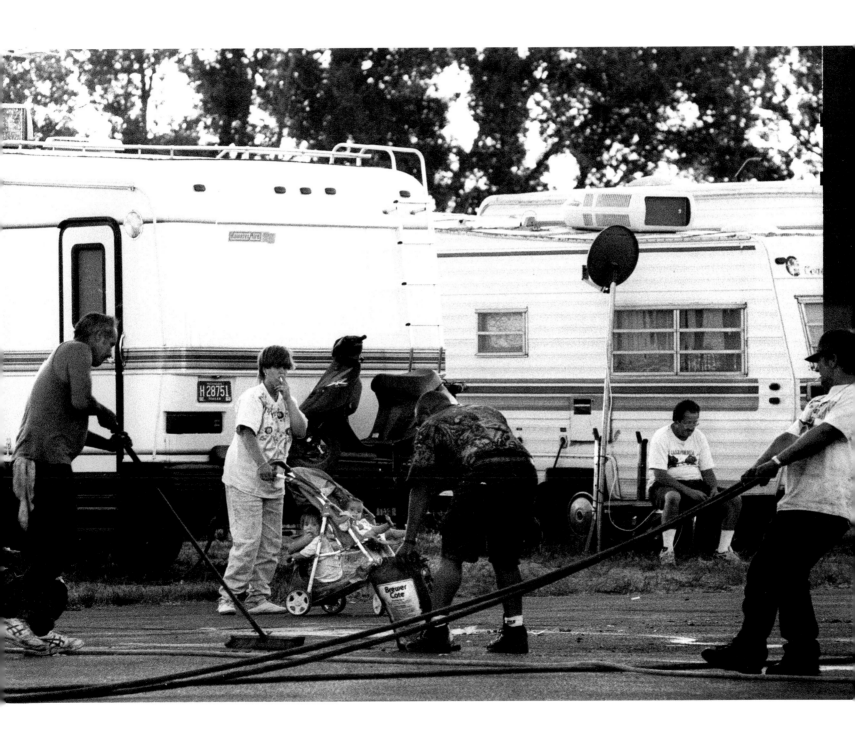

ARTIST STATEMENT

My first memory of going to a carnival was when I was thirteen years old. It was, more or less, my first experience of being with friends without parental supervision. We became screaming banshees marauding throughout the midway, riding the Tilt-a-Whirl, the Scrambler, the Round-Up, and hunting for packs of boys. It was a carnivorous time. That night I was whistled at by a twenty-something carny, the ultimate confirmation of my sexual debut. I felt so omnipotent, in my own tiny universe.

An old saying goes: "When the carnival comes to town, lock up your daughters and bring in the laundry." Is this the only reputation the carnival has? A carny named EZ once explained, "When we leave this town, these people won't think about the people running the carnival, but they will remember that the carnival was here."

Then who are carnies? I sought my answers in carnivals across the western plains of Nebraska and Wyoming, deep in the hollers of Appalachia, and through the valleys of California. The carnies told me who they were, and of their life with the carnival. I discovered that they are America's gypsies—the rock salt of this land, taking the hard knocks society gives and spinning them into sugar for the little child in all of us to enjoy.

Most importantly, the carnival showed me what it means to folks across this country. In my universe, I have my memory of the carnival; within yours, I am sure you have your own. Nearly everyone who has ever been to a carnival has carried away these indelible impressions. This collective memory of ourselves as youth becomes a part of our Americana.

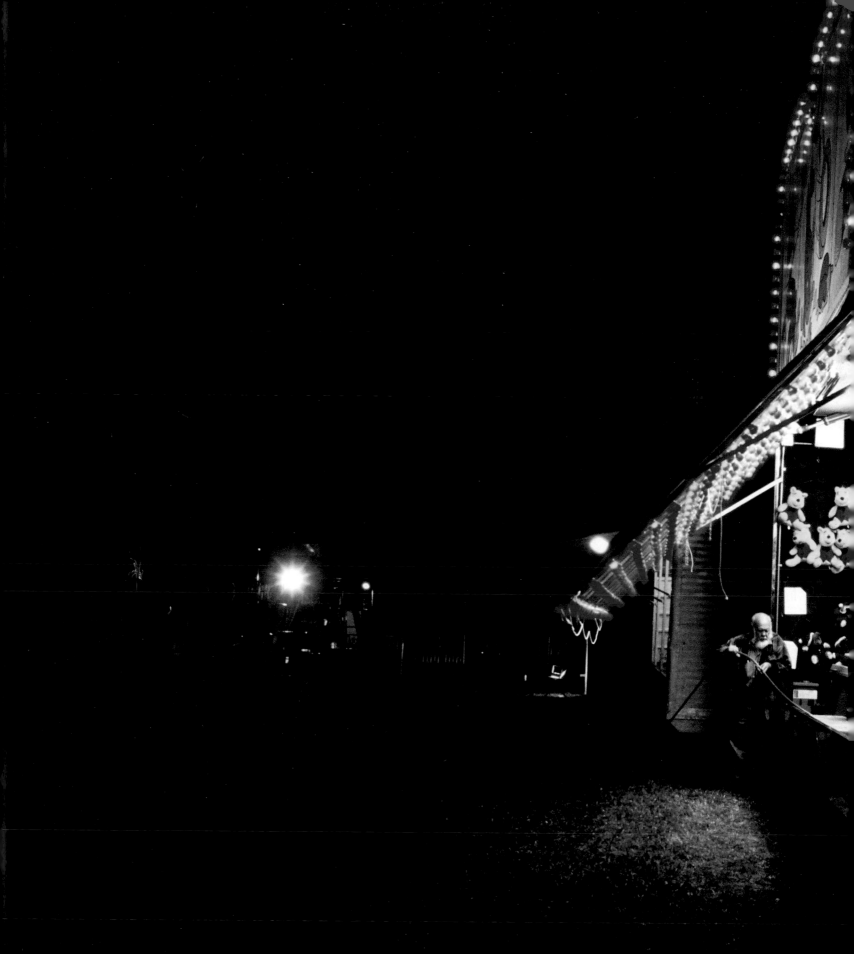

Acknowledgements

Specific thanks to the Showmen, women, Agents, Ride Jocks, Cotton Candy Makers, Candy Apple Dunkers, Funnel Cake Fryers, and Show Owners: Poochie Love, Hairy, "Bozo" Dave and Rachel Galyon, Dave Varney and his girlfriends, Ray, Stephanie and Hannah, Les "Corky" Powers, Butch and Judy Cory, EZ and Suzy, John Surber, Walter, Sharon, J.R., Jimmy Jam, Melinda, Sammy, Bertie, Mike, Katy and Kenny Hart, Tina Hart, "Junior" and Mary Kay Hart, Janie Wagner and her kids, Shorty, George, Kathy, The Anten Family, Virginia Ann, Robert, Buerger, Michael Ray, Angel, Art, Butch Red Feather, Henry Valentine, Butch Butler, E.J. Strates, Robert, Cat, Boo and Terry, Charlie, Bill White, Billy Jr, Cybo, Darryl, Marsha, Gypsy, Hippy, Charlie and Madge Dalton, Kenny and Crystal.

Additional thanks for the support, encouragement, and guidance to John Hunter, Terri Hunter, Janie Hunter, Jack Hunter, Megan Hunter, Shorty Hunter, Hydee Hunter, Beau Hunter, Joe McGraw, Lucy Phillips, Glen Scantelbury, Sarah George, Sara Terry, Lee Celano, Jim Storm, Johnny Leiberman, Tulsa Kinney, Anselm Spring, Marie Paule Goislard, Laura Lombardi, Maria Demopulos, Dermott Downs, Eric Gavin, Alison Murray, Ewa and Tasha Martinoff, Tom Christie, Van Gordon Sauter, Laura Kleinhenz, Nadine Kadey, Natalie Allowitz, Liz Gazzano, Chris Jacobson, Mazi Abul Jamal, Christianne Friess, Leor Levine, Michelle Llanos, Darius Hines, Blake Sell, Emma Bedard, Peter Fenton, Bill Smith, Nan Richardson, Erin Harney, Unha Kim and Kathleen and Tom Waits.

Carny: Americana on the Midway
An Umbrage Editions Book

Carny: Americana on the Midway copyright © 2007 by Umbrage Editions
Photographs copyright © 2007 by Virginia Lee Hunter
Interviews copyright © 2007 by Virginia Lee Hunter
Essay copyright © 2007 by Peter Fenton
Lyrics to "Circus" by Tom Waits and Kathleen Brennan, copyright © 2007 Jalma Music (ASCAP).
Used by permission. All rights reserved.

First Edition

ISBN 978-1-884167-66-9

Umbrage Editions
Publisher: Nan Richardson
Design: Jacqueline Bos, Erin Harney, Laura McBride
Copy Editor: Katherine Parr
Production: Unha Kim

Umbrage Editions
515 Canal Street #4
New York, NY 10013
www.umbragebooks.com

Distributed in North America by Consortium, www.cbsd.com
Distributed in Europe by Turnaround Publisher Services, LTD., www.turnaround-psl.com

Printed in China